BASEBALL
IN
LOUISVILLE

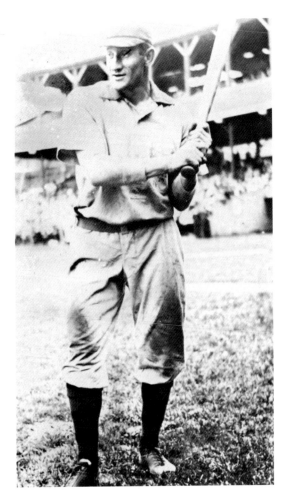

THE GREATEST EVER? Captured here in all his bowlegged, barrel-chested glory, Honus Wagner began his major-league career in Louisville on July 19, 1897. He played a number of positions for the Colonels, both infield and outfield, but never shortstop. Wagner was one of the team's leading hitters during his two and a half seasons here. He and several other players went to the Pittsburgh Pirates when the Louisville team folded after the 1899 campaign. In Pittsburgh, Wagner became a stellar shortstop and is considered one of the greatest players of all time. He hit at least .300 for 17 seasons in a row, ending with a lifetime batting average of .327. Honus Wagner was among the first group of players elected to the Hall of Fame in 1936. There is more on him in chapters one, three, and six. (Louisville Slugger Museum & Factory Archives.)

FRONT COVER: (Front) Honus Wagner completes another mighty swing. (Louisville Slugger Museum & Factory Archives.)

BACK COVER: The World's Biggest Bat at Louisville Slugger Museum & Factory is hollow and would hold 30,000 gallons of your favorite beverage. (© Hillerich & Bradsby Co.)

BACKGROUND: The Louisville Colonels played in the minor-league American Association for 61 seasons, from 1902 through 1962. (Louisville Slugger Museum & Factory Archives.)

BASEBALL
IN
LOUISVILLE

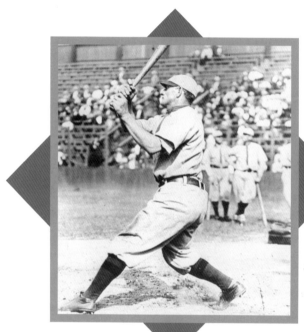

For Oliver,
Always
swing for
the fences!

Anne Jewell

Anne Jewell
Louisville Slugger Museum & Factory
with a foreword by Mary E. Barney

ARCADIA
PUBLISHING

Published by Arcadia Publishing
Charleston SC, Chicago IL, Portsmouth NH, San Francisco CA

Printed in the United States of America

Library of Congress Catalog Card Number: 2005936731

For all general information contact Arcadia Publishing at:
Telephone 843-853-2070
Fax 843-853-0044
E-mail sales@arcadiapublishing.com
For customer service and orders:
Toll-Free 1-888-313-2665

Visit us on the Internet at www.arcadiapublishing.com

*This book is dedicated to the employees of Hillerich & Bradsby Co.,
proudly producing the greatest baseball bats in the world since 1884.*

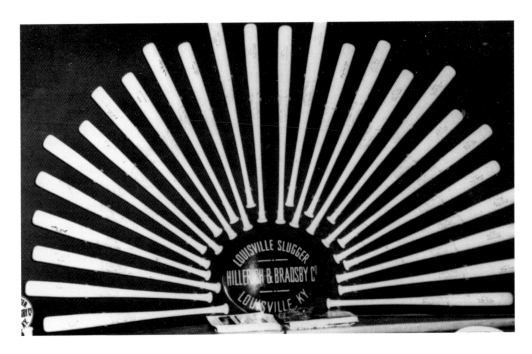

BAT FAN. Louisville Slugger bats fan out like a peacock tail in this 1950s promotional display. (Louisville Slugger Museum & Factory Archives.)

CONTENTS

Acknowledgments 6

Foreword 7

1. Major-League Scandals and Superstars: 1876–1899 9

2. The Colonels Lead Off at Eclipse Park: 1902–1922 25

3. The Parkway Field Era: 1923–1956 37

4. Fairgrounds Stadium, Goodbye for Now: 1957–1972 61

5. Baseball is Back in a Big Way: 1982–Present 71

6. Louisville Slugger, a Constant Through the Years: 1859–Present 91

Bibliography 128

ACKNOWLEDGMENTS

Special thanks go to: John Hillerich IV, and his father, Jack Hillerich, for fostering an environment open to new endeavors and supportive of employee development; Rick Redman and Nancy Martin for positive encouragement and support; Steve Lyverse and Suzanne Bowman for valuable counsel; Deana Lockman, Whitney Keeler, and Ashley Hoffmann for "taking care of business" while I concentrated on this project; John Jordan for beautiful reproductions of drawings over a century old; Candi Barajas for initial research and input; Paula Hawkins and Brenda Franck for researching employee information; Mary Barney for her humorous and insightful foreword; Lauren Bobier at Arcadia Publishing for her patience and guidance; the Veritas Society of Bellarmine University for inviting me to teach a class on this topic and starting me down this path; Andy Anderson and Bill Carner at the University of Louisville and Sharon Bidwell at *The Courier-Journal* for photographic research; my husband, Tom Crays, for doing more than his share around the house and his general loving support when I take on these types of things; my mother, Mary Ann Jewell, for her editing expertise, encouragement, and suggestions; my brother, Mike Jewell, for his encyclopedic and enthusiastic command of all things baseball; and Bill Dellinger for his significant and meticulous research and passionate assistance with this project. Even if, by some miracle, this book could have been completed without his help, it certainly would not have been half the volume that it is.

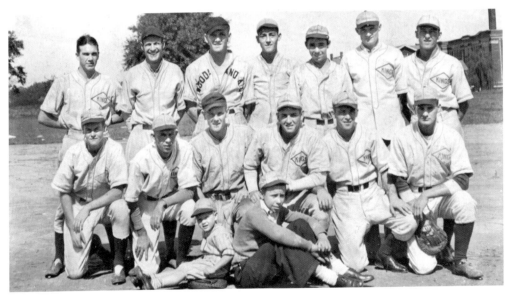

THAT BAT BOY SURE LOOKS FAMILIAR. He should. That's future Hall of Famer Harold "Pee Wee" Reese in the front row on the right. He was 13 years old when this picture of the New Covenant Presbyterian Church team (37th and Broadway) was taken in 1931. Pictured from left to right are (first row) K. Sparks Jr. and Reese; (second row) R. Harreld, H. McGrath, S. Alsop, P. Twyman, C. Craig, and J. Witt; (third row) J. Wilton, K. Sparks, M. Twyman, P. Patterson, C. Reese, R. Sutton, and C. Green. (University of Louisville Photographic Archives.)

FOREWORD

My love affair with Louisville baseball began 25 years ago when, in November 1981, I was hired as the first local employee of the Louisville Redbirds by then-owner A. Ray Smith. Professional baseball was returning to Louisville after a nine-year absence, and as a transplant from the baseball town of Chicago, I was delighted to be working in the sport that meant so much to me.

I vividly remember our opening night, April 17, 1982, when more than 19,000 cheering fans rose to their feet in old Cardinal Stadium as the Redbirds took the field to the strains of the national anthem. Tears welled up in my eyes then, as they have every opening day since. There is nothing like the first game of a new season!

As the senior member of the staff, I became the unofficial "mom" to the young men who have graced our playing fields ever since. I think back to the first day from spring training in 1983, when pitcher Ralph Citarella walked into the front office with a tall, good-looking, baby-faced young man carrying a pair of pink-colored cleats. This was Todd Worrell and he was holding the only pair of cleats he owned. He was to be our starting pitcher that night. "Mom" had a job to do. I gathered up the cleats and off I went to the shoemaker to have the cleats polished in Redbirds red.

The first four years or so, my job was mostly clerical. In 1986, Mr. Smith sold the club to Dan Ulmer, Jack Hillerich, and friends, and I took on the responsibilities of handling the team's travel and road housing, as well as overseeing clubhouse operations. I also had the good fortune to work with our major-league affiliates and their farm directors, such as Lee Thomas, Ted Simmons, Mike Jorgensen, and Tim Naehring.

The exhilaration I feel when I'm told a player is being "called up" to the major leagues cannot be described. I always try to send a player off with a hug and a wish that we never see him again—unless, of course, he's playing ball on television. I remember when Brian Jordan was leaving us for St. Louis. After his last game, he came looking for me to say "goodbye to Mom."

Times like these are the best for me, but there are down times too. It is always painful when I am told that a player is being released. Ordering an "end of the season" check (enough money to get him to his hometown) in May or June, when our season doesn't end until the first week of September, is frustrating. I try to see the player in person to wish him well and say a silent prayer that another club will pick him up.

To me, there is nothing like seeing a player who has been in a slump send a ball right up the middle for a hit . . . or uncrossing my fingers when a struggling pitcher finds his groove and confidently sets a batter down . . . or watching infielders turn a double play with ease. About the only thing that can top it is to see Louisville Slugger Field full of Bats fans that love the game as much as I do.

—Mary E. Barney
Director of Baseball Operations
Louisville Bats

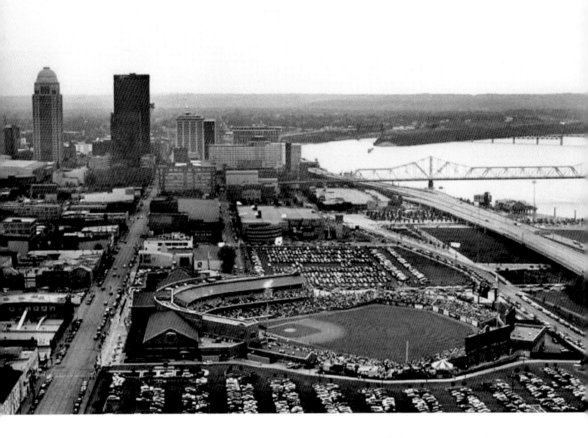

BATTER UP! The buildings of downtown Louisville overlook Louisville Slugger Field, home of the Louisville Bats. They've been the Triple-A affiliate of the Cincinnati Reds since 2000. Originally chartered in 1780, Louisville, Kentucky, is the 16th largest city in the nation. The Ohio River rolls by in the upper right corner of this photograph. In centuries past, the river was a major transportation route for baseball fans traveling by steamboat between Cincinnati and Louisville. (Louisville Bats.)

Major-League Scandals and Superstars

1876–1899

Some historians believe the first "official" baseball game in Louisville took place in April 1865. According to folks who were there, the visiting Nashville Cumberlands were trounced 22-5 by Louisville on a diamond at Duncan and Nineteenth Streets, located on the city's west side. Local fans were still learning the game, and many in attendance did not realize the hometown team had won until Nashville's female scorekeeper hiked up her skirts and hauled herself on top of her table to announce the outcome. Baseball in Louisville was off to a rousing start.

Ten years later, in December 1875, Louisville hosted key discussions in the formation of a new major league, the National League. William Hurlburt, disgusted with the gambling, chicanery, and other troublesome aspects that were besmirching baseball, set out to establish a clean, respectable league. The inaugural teams in the National League were his own Chicago White Stockings, the Cincinnati Red Stockings, the St. Louis Browns, the Boston Red Caps, the Hartford Dark Blues, the Philadelphia Athletics, the New York Mutuals, and the Louisville Grays.

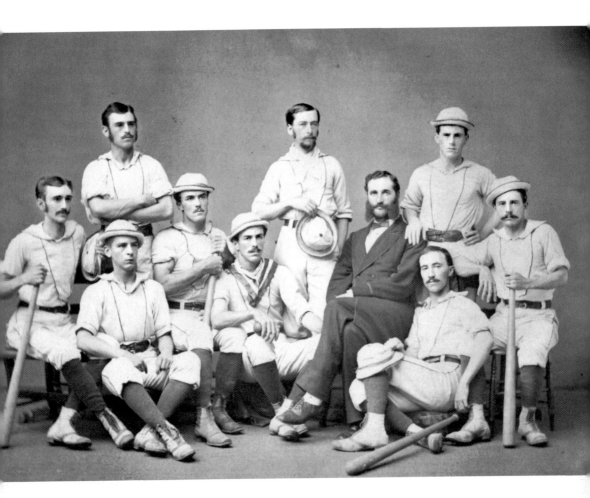

Yes, But What Were They Wearing? Before professional baseball arrived in Louisville, the city had an active baseball scene with clubs and enthusiastic amateur and semi-professional players. The city's earliest known box score appeared on July 15, 1858, in the *Louisville Daily Democrat*. The "Louisville Base Ball Club" played on Tuesday and Thursday afternoons. The paper noted that the club wore uniforms of blue cottonade pants, white flannel shirts with blue piping, dark blue caps, and leather belts. The nattily dressed gentlemen pictured here are the semi-professional Louisville Eagles of 1874. The team apparently survived the shellacking they received several years earlier, when they lost to the Cincinnati Red Stockings 94-7. Pictured from left to right are (first row) Harry Truman, Will Coleman, W. Osborne, Allen Polk Houston, Allan McDonald, George Bayless, and Kenneth McDonald; (second row) Thomas Muir, William S. Bodley, and ? Bors. (The Filson Historical Society, Louisville, Kentucky.)

MAJOR-LEAGUE SCANDALS AND SUPERSTARS

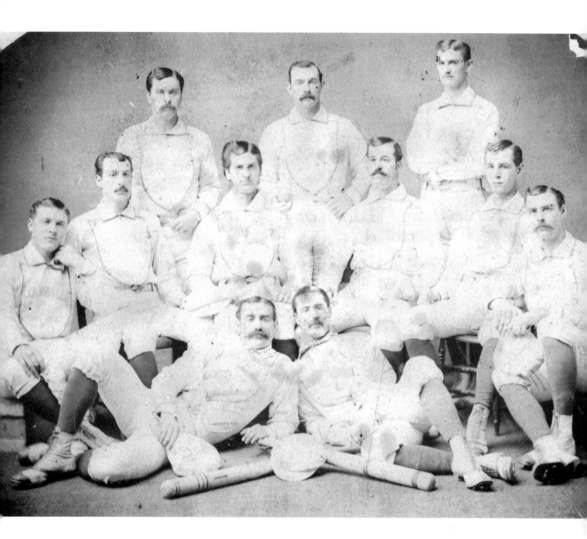

LOUISVILLE HITS THE BIG LEAGUE. The city's first major-league team strikes a pose. The 1876 squad made history in its season opener against Chicago on April 25. They were on the losing end of the first shutout in the majors, going down 4-0. Six thousand people paid 10¢ to come to the first game. Louisville wrapped up its inaugural big-league season in fifth place with 30 wins and 36 losses. The team played in the Louisville Base Ball Park, which was situated where St. James Court now stands in historic Old Louisville. Home plate was located at the intersection of Fourth and Hill Streets. The diamond was used until around 1883. Fans could sit in the stands or on a hill behind the outfield fence. During games, Fourth Street was lined with fancy carriages belonging to upper-crust Louisvillians out for a day at the ballpark. Pictured from left to right are (first row) George Bechtel and Johnny Ryan; (second row) John Carbine, Bill Hague, Chick Fulmer, John Chapman, Joe Gerhardt, and Art Allison; (third row) Scott Hastings, Jimmy Devlin, and Charles Snyder. (National Baseball Hall of Fame, Cooperstown, New York.)

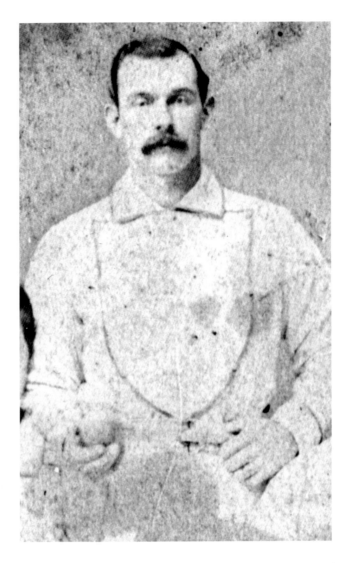

SCANDAL! Things sure seemed promising for Louisville's 1877 squad. By late August, they were poised to win the pennant. Then they lost every game on their last road trip, and Boston captured the league championship. An investigation proved several players had indeed conspired with East Coast gamblers to throw games. Telegrams with the code word "sash" were used to communicate plans during the ugly deed. Four Louisville players were kicked out of baseball. Star pitcher Jimmy Devlin made one last and rather pathetic appeal on his knees to William Hurlburt, the league president. As the story goes, Hurlburt gave him $50 of his own and told him, "That's what I think of you personally; but damn you, Devlin, you are dishonest. You have sold a game and I cannot trust you. Now go and let me never see your face again, for your act will not be condoned as long as I live." Devlin was out of luck, and Louisville was out of the big leagues for the next four seasons. This was professional baseball's first big scandal, and it was a doozy—a devastating, embarrassing blow to Louisville, and one that cost the city its major-league team. (National Baseball Hall of Fame, Cooperstown, New York.)

NOW WHAT? After the shameful wrongdoing of 1877, Louisvillians still wanted to play and watch baseball, but with no major-league team to call their own, squads like this semi-professional Louisville Eclipse team from 1880 helped fill the void. (University of Louisville Photographic Archives.)

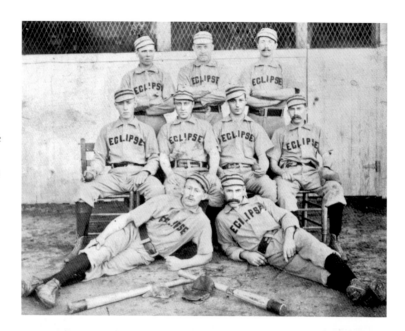

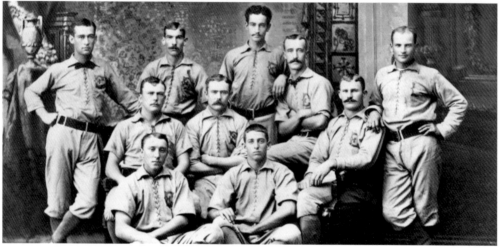

THE BEER BALL LEAGUE. Louisville got back in the big leagues in 1882 as a charter member of the American Association, a league formed to rival the National League. Along with lower ticket prices, the upstart American Association also sold alcohol at games (earning its nicknames the "Beer Ball League" and the "Beer and Whiskey League") and scheduled games on Sundays. The American Association came to an end after 1891, but its lower prices, alcohol sales, and Sunday games were adopted by the National League and by the American League when it was formed. This is Louisville's first American Association squad, the 1882 Louisville Eclipse. Pictured from left to right are (first row) John Reccius and William Van Winkle "Chicken" Wolf; (second row) Dan Sullivan, Denny Mack, and Guy Hecker; (third row) Leech Maskrey, Pete Browning, Tony Mullane, Bill Schenk (with arms folded), and John Strick. (University of Louisville Photographic Archives.)

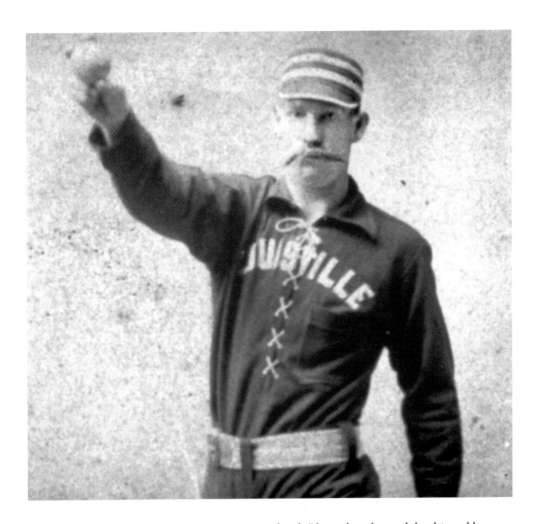

THE GLADIATOR. Pete Browning was a superstar on the diamond and a sad story off. He earned two batting crowns with the Louisville Eclipse. In 1882, with a .388 average, he became the first major-league rookie to win a batting championship. His second one came in 1885 with a .362 mark. In 1887, he averaged .402, but that wasn't enough to win the batting title that year. Browning's lifetime average of .341 is the 11th highest in major-league history and the highest of any player eligible for (but not in) the Hall of Fame. Browning's defensive play was weak, and while his heavy drinking made for many wild and colorful stories, it also contributed to the tragic circumstances of his life. He was known to say, "I can't hit the ball until I hit the bottle." It was later learned that his problems may have started early in life with an ear infection that led to crude medical operations, partial deafness, illiteracy, and alcoholism. In his last years, Browning was in and out of psychiatric and medical facilities. He died in 1905 at the age of 44. Different explanations exist for his "Gladiator" nickname, ranging from his warlike, competitive approach to the game, to his clashes with the press, his challenges fielding, and his battles with alcohol. Given his prowess at the plate, Browning was also known as "The Louisville Slugger." That nickname lives on a century after his death, thanks to the famous bat maker based in Browning's hometown. (Louisville Slugger Museum & Factory Archives.)

SWITCH-PITCHIN' LADIES' MAN. Tony Mullane was the first to pitch right- and left-handed in a major-league game. He did it for Louisville on July 18, 1882. That was the only year he played here, posting a 30-24 record. His dazzling career included a 285-220 win-loss record and five seasons with 30 wins. Perhaps his most memorable contribution to baseball has more to do with his great looks than his great pitching. He wasn't called "the Count" and "Apollo of the Box" for his ERA. Throngs of women came to see the handsome hurler when he pitched, inspiring the creation of "Ladies Day" as a promotional shtick still used today. (*The Sporting News.*)

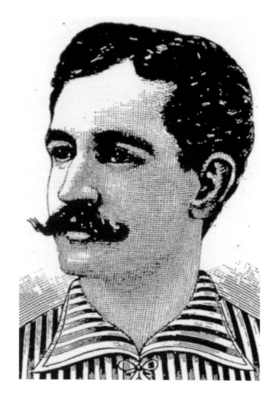

CLUB.		INNINGS.								
NAME PLAYER.	POSITION.	1	2	3	4	5	6	7	8	9
BROWNING....	Centre Fielder.		2B.				2B.			
WOLF	Right Fielder.						HR.			
IECKER	Pitcher........									
GERHARDT.. ..	Second Base...									
JASKREY......	Left Fielder...									
REQUIUS	Third Base....									
SULLIVAN ...	Catcher.									
LATHAM	First Base. ...									
McLAUGHLIN...	Short Stop....									
TOTALS...			3	0		0	0			
UMPIRE—										

KEEPING SCORE. This scorecard is from 1884. Inside, someone at the Eclipse game penciled in the action. Batting leadoff, the great hitter Pete Browning had two doubles during the contest, and "Chicken" Wolf launched a home run in the second inning. (The Filson Historical Society, Louisville, Kentucky.)

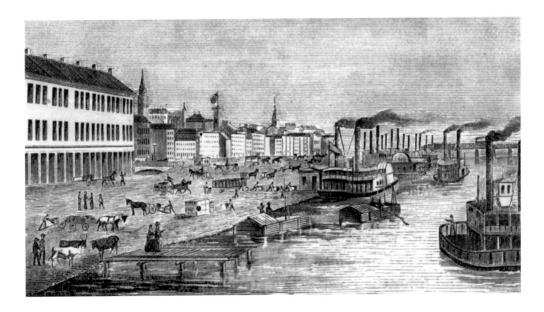

A STEAMBOAT TOWN. Louisville is perched on the upper end of a series of Ohio River rapids known as the Falls of the Ohio. This location made the city a significant destination and steamboat port in the 19th century. This woodcut depicts Louisville's bustling wharf in the late 19th century. Rivers were the interstates of that era, and many baseball fans traveled by steamboat to catch games in Louisville and elsewhere. (The Filson Historical Society, Louisville, Kentucky.)

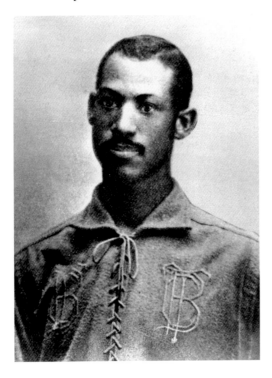

BEFORE JACKIE ROBINSON. While Jackie Robinson is recognized as being the first African American in the major leagues, his groundbreaking achievement occurred in 1947—the modern era of baseball. In 1884, Louisville opened its season on May 1 against the Toledo Blue Stockings, whose starting catcher and clean-up hitter was Moses Fleetwood Walker. It was his major-league debut, making him the first African American in the majors, and it happened on Louisville turf. *The Courier-Journal* reported that a large crowd came to the game and that "Walker, the colored catcher, who has been spoken of as something of a wonder, appeared to be badly rattled, and managed to make all the errors himself." Louisville won 5-1. The losing pitcher was former Eclipse player Tony Mullane. (The Toledo–Lucas County Public Library.)

MAJOR-LEAGUE SCANDALS AND SUPERSTARS

EXCURSION!

on the Steamer
~MAGGIE HARPER,~
TO
LOISVILLE,
SATURDAY, MAY 17th, '84

The best of order. Seats for everybody. Prof. Hollis' Orchestra, assisted by Will Wright. No Liquors sold on the boat. This will be the Boss Excursion of them all.

Look at the List of attractions in Louisville on the 17th.

You Can't Afford to Miss it.

McCauley's Theatre--Clara Morris in New Magdaline and Article 47. Whalen's Theatre, American Flats. Louisville Jocky Club, Spring Meeting; 5 races Saturday, 44 entries first race at 2.30. Base Ball Park, game called at 2.30.

The Boat will leave Louisville at 12 o'clock at night, giving those who attend the races and base ball game an opportunity to go to the Theatre at night.

LEAVES CARROLLTON at 5.30 o'clock
" MADISON, " 7 o'clock

IT'S A GO, RAIN OR SHINE.

Fare, Adults, Round Trip 75 Cts.
Fare, Children, Round Trip 25 cts.

Staterooms $1,00 additional. Telephone Capt. Andy Henry at the Wharf boat if you want one.

Remember the day May 17,

SAM. S. FEARN, Master.

N. B. NEXT EXCURSION, MAY, 24.

IT'S A GO, RAIN OR SHINE. This 1884 broadside advertises a round-trip steamboat adventure between Louisville and Carrollton, Kentucky. A 2:30 game at Base Ball Park (also known as Eclipse Park) is promoted as part of the fun. (The Filson Historical Society, Louisville, Kentucky.)

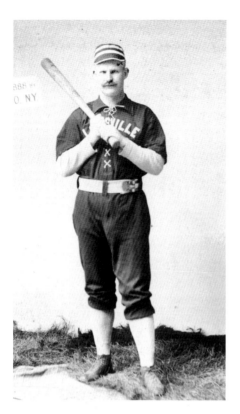

DOUBLE THREAT. In 1886, Guy Hecker made history as the first and only pitcher to snag a batting title. He batted .341, edging out teammate Pete Browning's .340 mark, and also won 26 games as a pitcher. He played eight of his nine major-league seasons with Louisville, which included pitching a no-hitter in 1882 and capturing the triple crown of pitching in 1884 with a 52-20 record, 385 strikeouts, and an ERA of 1.80. On top of all that, Hecker had a .283 career batting average. (Louisville Slugger Museum & Factory Archives.)

ANOTHER SWITCH PITCHER. On May 9, 1888, Tony "Icebox" Chamberlain became the first and only switch pitcher to win a game. He threw both right- and left-handed during Louisville's 18-6 victory over Kansas City. Several theories have been offered for his nickname, including his cool demeanor and his short, broad build. (University of Louisville Photographic Archives.)

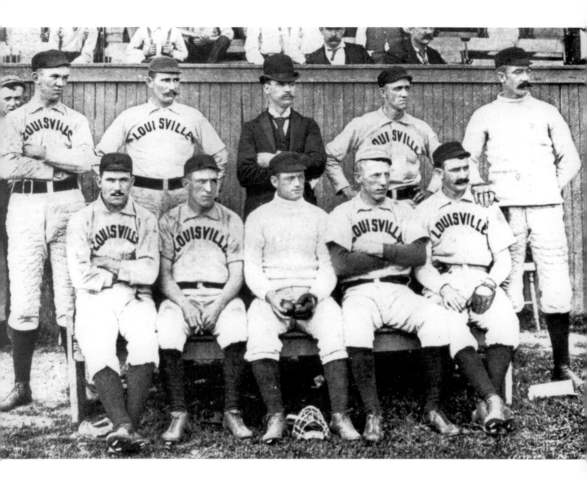

STRIKE ONE. It's no wonder these guys aren't smiling. The 1889 Louisville team offered up several "firsts" for the record books, including the first player strike in major-league baseball. In the midst of a dismal season, the team owner decided to fine players for errors during games. When several team members threatened not to play, he instituted a fine for not playing. Six players went on strike for one game, and the American Association agreed to investigate the situation. The next month, some local stockholders bought out the owner. The team became the first in the majors to lose 100 games (111, to be exact). This bunch was the first major-league team to "disappear." In the midst of the Johnstown Flood in Pennsylvania, the team's train was stranded and unable to communicate its whereabouts for two days. The unsuccessful search for the missing team fueled various theories of their demise but not much sympathy, as the *Louisville Commercial* reported: "If the entire team had been standing in front of the Johnstown reservoir when it broke . . . the people of Louisville would have viewed the calamity as a just visitation of Providence." Much brighter days awaited the team next season. Pictured from left to right are (first row) Farmer Weaver, John Ewing, Scott Stratton, Red Ehret, and Ed Flanagan; (second row) Dan Shannon, Farmer Vaughn, ? Brown, John Galligan, and Chicken Wolf. (National Baseball Hall of Fame, Cooperstown, New York.)

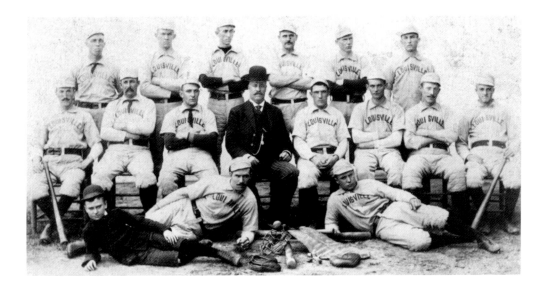

WE ARE THE CHAMPIONS—SORT OF. The 1890 season was an exciting one for Louisville baseball. Louisville went from worst to first in back-to-back seasons and won the pennant. Such a dramatic turnaround had never happened before. They were matched up against the Brooklyn Bridegrooms in what should have been a nine-game World Series. The teams were tied with three wins apiece, when bad weather and low attendance postponed the rest of the championship series until the following season. The games were never played, making Louisville and Brooklyn both champions for 1890. (Louisville Slugger Museum & Factory Archives.)

WHO'S AFRAID OF CHICKEN WOLF? Pitchers, that's who. William Van Winkle "Chicken" Wolf was Louisville's third player to win a major-league batting title. He hit .363 in 1890, the year Louisville made it to the World Series. Wolf's career batting average was .290. Chicken Wolf earned his memorable nickname from teammate Pete Browning after Wolf downed a large batch of stewed chicken before a game and then committed a number of errors. (University of Louisville Photographic Archives.)

BASEBALL BALLET. This action shot from 1889 shows the first Eclipse Park at Twenty-Eighth and Elliott Streets on Louisville's west side. Games here date back to around 1874, and it was the home field for Louisville's American Association and National League professional teams from 1882 to 1893. After fire swept through this stadium in 1892, a second Eclipse Park was built nearby at Twenty-Eighth and Broadway. Louisville joined with the National League in 1892 and played at the second Eclipse Park from 1893 to 1899, when it, too, was wiped out by fire. (University of Louisville Photographic Archives.)

THE GAME MUST GO ON. When the first Eclipse Park caught fire on September 27, 1892, the team built seats and a new fence within 48 hours so that the scheduled games would not be interrupted. This drawing appeared in the *Louisville Journal* on September 29 under the headline, "Played Amid Ashes, Spectators Perch on Ruins and See Two Games." About 700 people came, many of them motivated by curiosity about damage. During the first game, a fire broke out under the bleachers. Not surprisingly, "it was first noticed by several men sitting directly over the blaze." A dozen buckets of water doused the danger as the game played on. (Hand drawing reproduced by John Jordan. Louisville Slugger Museum & Factory Archives.)

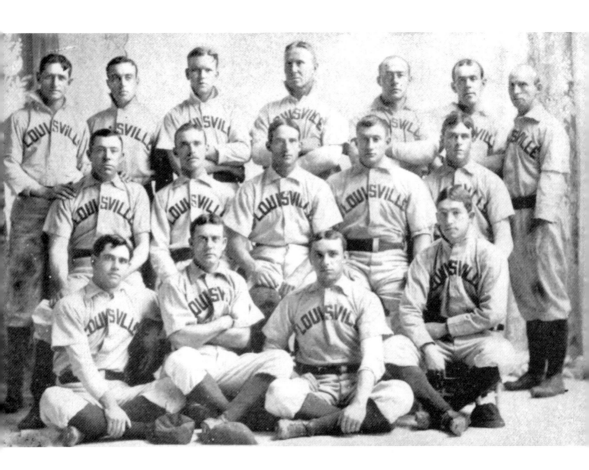

WHAT A START. When 21-year-old Fred Clarke joined the Louisville Colonels in June 1894, he refused to suit up for his first game until he was given his $100 bonus. He promptly proved his worth, going five-for-five in his debut—a record for a rookie to this day. He was Louisville's player-manager from 1897 to 1899. A great outfielder with a fiery personality, Clarke was also the top batter on the team on a regular basis, even besting teammate Honus Wagner. Clarke once fined Wagner $25 after Wagner hit a home run for Louisville—Clarke had told him to bunt. When Louisville folded into the Pittsburgh franchise after the 1899 season, "Cap" Clarke went on to manage there until 1915, winning three pennants and one World Series. Clarke's career batting average was .312 and his winning percentage over 19 years as a manager was .576. He was elected to the Hall of Fame in 1945. Pictured here is the Louisville team of 1897, Honus Wagner's first year in the majors. From left to right are (first row) Roy Evans, Bert Cunningham, Chick Fraser, and Charlie Dexter; (second row) Bill Clark, Billy Clingman, Fred Clarke, Honus Wagner, and Bill Magee; (third row) Joe Dolan, Abbie Johnson, Bill Hill, Perry Werden, Bill Wilson, Dick Butler, and General Stafford. (University of Louisville Photographic Archives.)

A HANDFUL. Words like eccentric, man-child, and flaky have been used to describe George "Rube" Waddell. A left-handed hurler with great control, Waddell was also an alcoholic with a variety of unique pursuits and interests, including fire engines (which he chased) and alligators (which he wrestled). He broke into the majors with the Louisville Colonels in 1897. That year he posted an 0-1 record. In 1899, he went 7-2. Waddell went on to play for Pittsburgh, Chicago, Philadelphia, and St. Louis, leaving behind him a string of barkeeps who believed they were displaying *the* authentic ball from Waddell's 20-inning victory over Cy Young, which he "gave" each one of them in exchange for drinks. He entered the Hall of Fame in 1946 with a 2.16 career ERA and a 193-143 record. (University of Louisville Photographic Archives.)

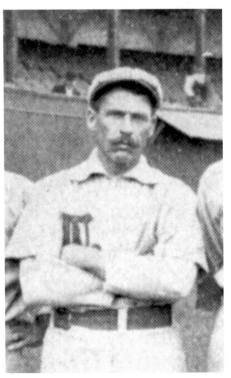

THE "AMAZING DUMMY." By the time William "Dummy" Hoy joined Louisville in 1898, he already had over 10 years of major-league experience. His lasting contribution to baseball came about because of his deafness. Hoy contracted spinal meningitis as a baby, and by age two, he had lost his hearing and ability to speak. He dreamed of being a professional baseball player and got his chance in 1885. When Hoy looked behind him in the batter's box to read the umpire's lips, pitchers tried to throw again, before he was ready. Hoy established a system of hand signals with his third-base coach, who rapidly relayed the ump's call to Hoy via hand motions. The use of hand signs for ball and strike calls became the norm as umpires began to do it, making the calls understandable for other players and fans out of earshot. While Hoy's nickname, "Dummy," may be considered politically incorrect these days, he embraced it his entire life. (University of Louisville Photographic Archives.)

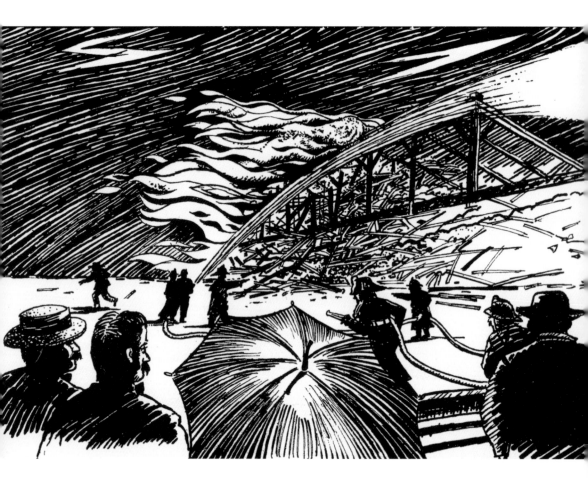

UP IN FLAMES. Fire swept through the second Eclipse Park on August 12, 1899. The flames were probably started by a lightning strike. This drawing is reproduced from the original that ran in the *Louisville Times* on August 13. A temporary grandstand was built, but it didn't much matter, as major-league baseball was about to come to an end in Louisville. The National League voted to reduce itself to eight teams and dropped Baltimore, Cleveland, Washington, and Louisville. Colonels owner Barney Dreyfuss struck a deal with Pittsburgh and became owner of that franchise. He delivered his top talents from Louisville, including Honus Wagner and Fred Clarke. With the former Colonels contingent, the Pirates morphed into a powerhouse. The last major-league game for Louisville took place at Eclipse Park on September 2, 1899. Louisville beat Washington that day 25-4. (Hand drawing reproduced by John Jordan. Louisville Slugger Museum & Factory Archives.)

THE COLONELS LEAD OFF AT ECLIPSE PARK

1902–1922

When Louisville's team folded after the 1899 season, that was the end of the majors in the River City. It was an impressive run, with six future Hall of Famers suiting up for Louisville during that era: Hughey Jennings, Fred Clarke, Dan Brouthers, Jimmy Collins, Honus Wagner, and Rube Waddell.

Never again would Louisville have a big-league entry, but it didn't take long for professional baseball to resurrect itself in a town that so loved the sport. In 1902, the Louisville Colonels became charter members of a new baseball league, the American Association. While it had the same name as the major league Louisville played in from 1882 to 1899, this American Association was the minors. A long and exciting run of minor-league action in Louisville got underway.

Major-league stars also swung into town on a regular basis with appearances and exhibition games, including Ty Cobb, Joe Jackson, Walter Johnson, Nap Lajoie, Christy Mathewson, Tris Speaker, Casey Stengel, John McGraw, and Connie Mack.

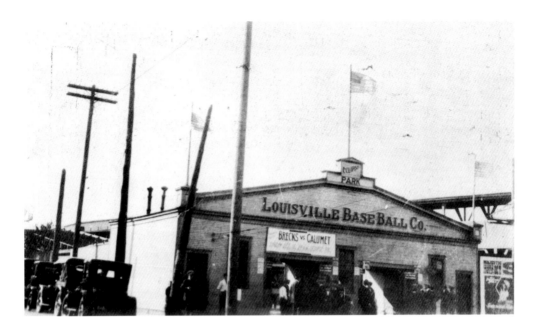

THE THIRD ECLIPSE PARK. The Colonels' owner, George "White Wings" Tebeau, hunted for a spot to build a new park. When his first choice at Seventh and Algonquin Streets was too far away for the trolleys, he opted for Seventh and Kentucky Streets. The third Eclipse Park was built quickly and opened in 1902, seating 8,500. The Colonels called it home for 21 years. (University of Louisville Photographic Archives.)

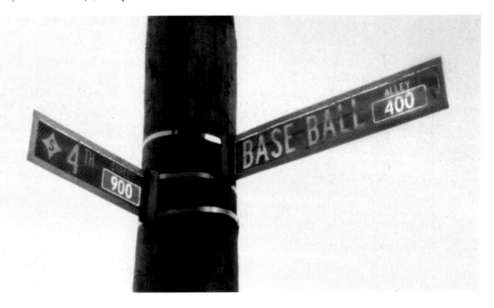

BASE BALL ALLEY. This sign next to Memorial Auditorium on Fourth Street still marks the route followed by baseball fans as they walked from the trolley stop on Fourth to Eclipse Park at Seventh and Kentucky. (Anne Jewell, Louisville Slugger Museum & Factory.)

THE COLONELS LEAD OFF AT ECLIPSE PARK

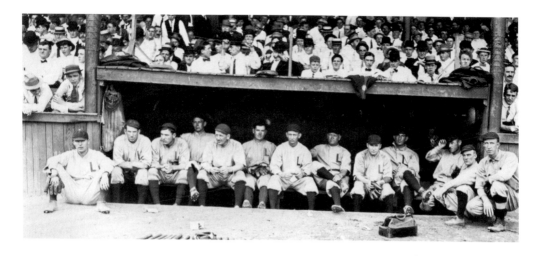

FIRST OF MANY PENNANTS. With fans packed in the stands above them, the Colonels of 1909 peer from their dugout. This team won Louisville's first of eight pennants in the American Association. The other pennant-winning years were 1916, 1921, 1925, 1926, 1930, 1946, and 1959. The players are not identified, except for manager Heinie Pietz, who is eighth from the left with his hand on his ankle. Pietz was the team's 38-year-old catcher when he was promoted to player-manager during the 1909 season. (University of Louisville Photographic Archives.)

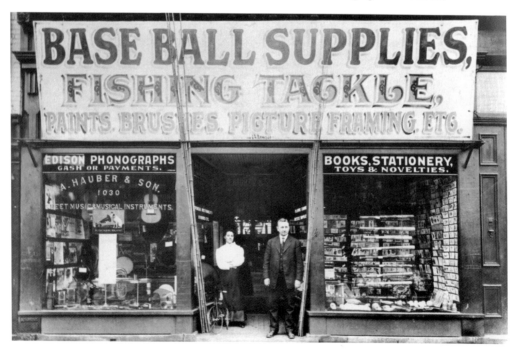

BASE BALL SUPPLIES. At 1030 West Market, A. Hauber and Son offered everything from toys to paint to sheet music. This photograph was taken c. 1909. (University of Louisville Photographic Archives.)

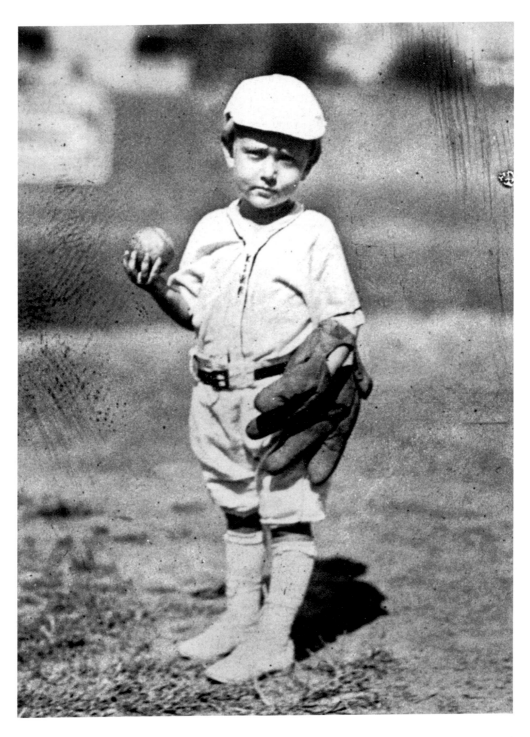

PORTRAIT OF THE PLAYER AS A YOUNG MAN. A little fan grips a baseball with one hand while most of his left arm disappears into his glove. This charming portrait was possibly snapped at Eclipse Park. (University of Louisville Photographic Archives.)

THE COLONELS LEAD OFF AT ECLIPSE PARK

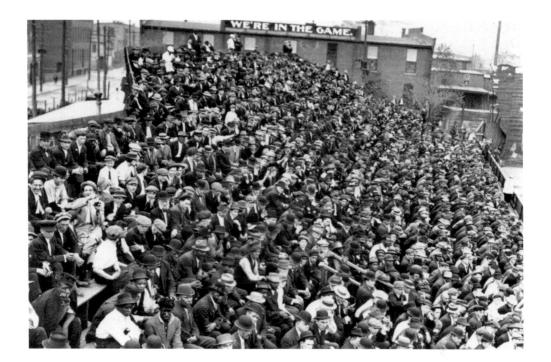

WE'RE IN THE GAME. The left-field bleachers at Eclipse Park are pictured in 1911. This shot shows the bleachers were integrated, but over 40 years would go by before black and white fans sat side by side in Louisville's grandstand.(University of Louisville Photographic Archives.)

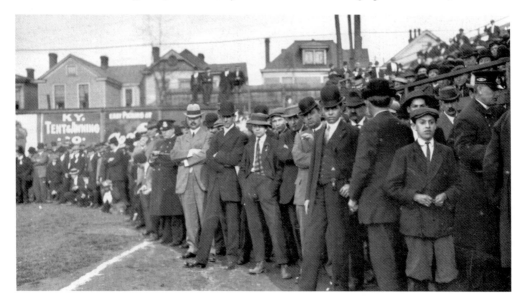

STANDING ROOM ONLY. An overflow crowd takes in the action from right field. The houses peeking over the outfield wall were part of the Irish immigrant neighborhood still known today as Limerick. (University of Louisville Photographic Archives.)

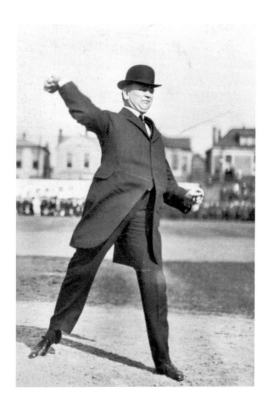

A DAPPER DELIVERY. Louisville mayor W. O. Head delivers the first pitch at the 1912 home opener in Eclipse Park. According to *The Courier-Journal*, "While the mayor's 'spitter' was working fine, his control was bad," and the ball was tossed high. (University of Louisville Photographic Archives.)

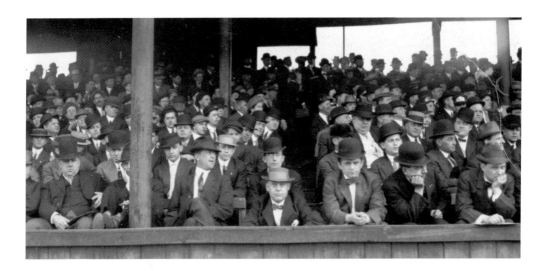

WE ARE NOT AMUSED. Attendance at the 1912 opener was a record-setting 10,000 people; apparently many of them were unhappy men in hats. The 6-4 loss to Minneapolis could account for the dour expressions displayed here. Things didn't get much better that season, as the Colonels finished second-to-last in the American Association, 40 games back, with 66 wins and 101 losses. (University of Louisville Photographic Archives.)

THE COLONELS LEAD OFF AT ECLIPSE PARK

Is There a Doctor in the House? Yes. Pictured here at Eclipse Park in 1914 is Dr. George C. Leachman, the club physician. He became a major in the U.S. Army during World War I and returned to practice in Louisville after that. (University of Louisville Photographic Archives.)

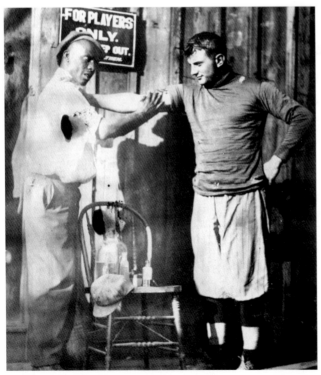

Strong-Arm Him. The throwing arm of Louisville catcher Verne "V. J." Clemons (right) gets a rubdown from trainer Phil Bean. Clemons played for the Colonels from 1913 to 1915 and again in 1917. He hit .320 for the St. Louis Cardinals in 1921. (University of Louisville Photographic Archives.)

BASEBALL IN LOUISVILLE

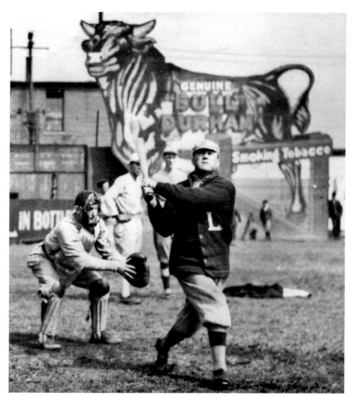

SWING FOR THE FENCES. Louisville manager Jack Hayden takes a cut in 1914. Hayden was the American Association batting champ in 1908, when he batted .316 for Indianapolis. Louisville catcher V. J. Clemons is crouched behind Hayden. The Bull Durham sign towering over the outfield was a staple in many ballparks at the time. Players received a cash reward from the tobacco company if they hit the sign during a game. (University of Louisville Photographic Archives.)

A WINNING MANAGER. Joe McCarthy did double duty as a player-manager for 7 of his 10 seasons with the Louisville Colonels. He joined the team in 1916, playing second base for the Colonels on their way to the pennant that season. His stint as manager began in 1919 and included two pennant-winning campaigns in 1921 and 1925 plus a championship in the Little World Series in 1921. His success as a minor-league manager was just a prelude to his big-league career, where he still holds the record as the winningest manager of all time. McCarthy racked up a .615 winning percentage, including seven World Series titles. He was elected to the Hall of Fame in 1957. (University of Louisville Photographic Archives.)

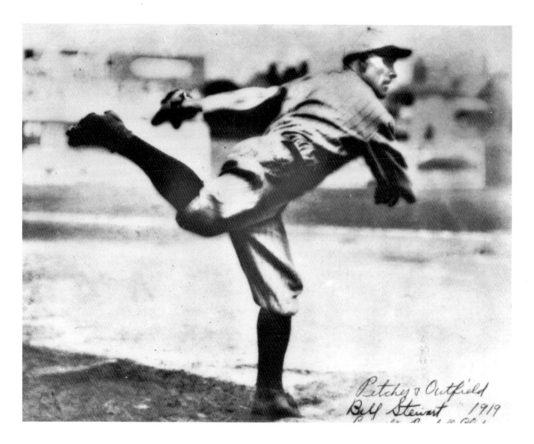

Pitchy & Outfield
Bill Stewart 1919

POETRY IN MOTION. This graceful impression captures Louisville pitcher Bill Stewart at the completion of his pitching motion in 1919. (University of Louisville Photographic Archives.)

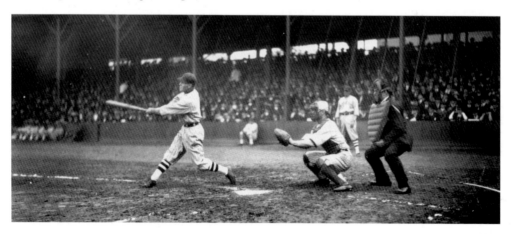

THE SEASON STARTS. Here is Eclipse Park on Opening Day, 1921. The Colonels won this game and went on to capture the pennant that season. (University of Louisville Photographic Archives.)

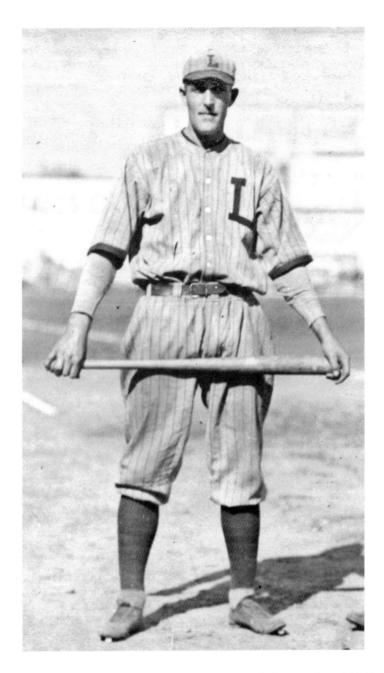

HECKUVA HITTER. Jay Kirke bounced around the big leagues from 1910 to 1918, but his weak defense and eccentricities prevented him from making a go at a consistent major-league career. An outfielder and first baseman, Kirke compiled more than 3,000 hits over the course of his minor-league years, which included a stint with the Colonels from 1916 to 1922. He is pictured here at Eclipse Park during the 1921 Little World Series, which Louisville won five games to three over Baltimore. Kirke led the league in batting that year with a .386 average. He batted over .300 seven years in a row with Louisville. (Louisville Slugger Museum & Factory Archives.)

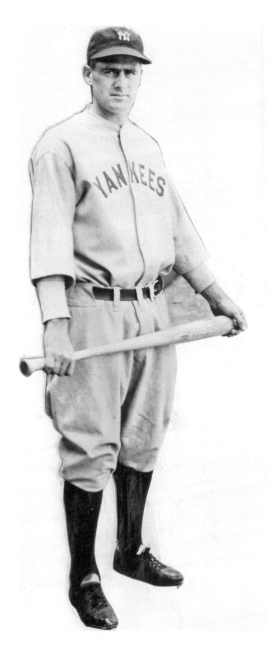

THE KENTUCKY COLONEL. Earle Combs was born in 1899 in Pebworth, Kentucky (near Lexington), and got his professional start as a Louisville Colonel. During the 1922 season, he batted .344 and topped that impressive mark with a .380 average the following year. He joined the New York Yankees in 1924, where he served as a speedy and productive leadoff hitter and center fielder. Combs led the American League in triples in 1927, 1928, and 1930. He crashed into an outfield wall in 1934 and suffered a career-ending injury. Combs wrapped up his major-league career with a .325 batting average and was voted into the Hall of Fame in 1970. (Louisville Slugger Museum & Factory Archives.)

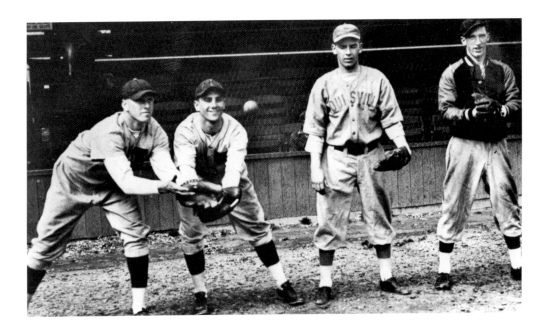

GIVE IT THE OL' PEPPA! Louisville Colonels play some pepper as a warm-up at Eclipse Park. (University of Louisville Photographic Archives.)

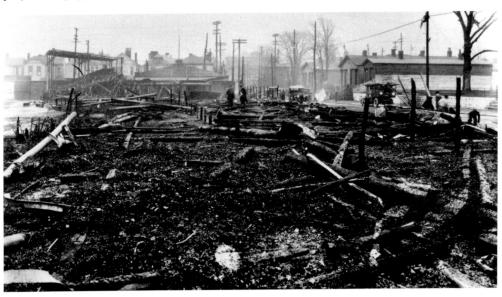

THIRD TIME NOT THE CHARM. Fire destroyed the first two Eclipse Parks. Could the third one escape such a fate? One look at this photograph provides the answer. In the early-morning hours of November 20, 1922, flames devoured the grandstand and bleachers at Eclipse Park. The fire was under control at 3:20 a.m., but some nearby houses were scorched. Plans to replace the wooden structure with a concrete one had been discussed before the fire, but now a concrete park would be built in a new location. (University of Louisville Photographic Archives.)

THE COLONELS LEAD OFF AT ECLIPSE PARK

THE PARKWAY FIELD ERA

1923–1956

From the charred ruins of Louisville's third and final Eclipse Park grew a new era that would play out in a new ballpark. Parkway Field was unlike any other baseball stadium built before it in Louisville. For starters, it was steel and concrete. It was also larger than earlier parks and featured a patented seat design.

The next 33 years at Parkway would see hundreds of young Colonels come through the system, including several future Hall of Famers. Louisville also continued to welcome established major-league and Negro League superstars like Babe Ruth, Lou Gehrig, and Satchel Paige for exhibitions and charity fund-raisers.

Attendance at minor-league ball games began to decline in the 1950s, as the majors expanded into other cities and televised baseball games (and other shows) kept people entertained at home. By the end of the Parkway Field era, Louisville's team was struggling with low attendance, but they found ways to keep on swinging.

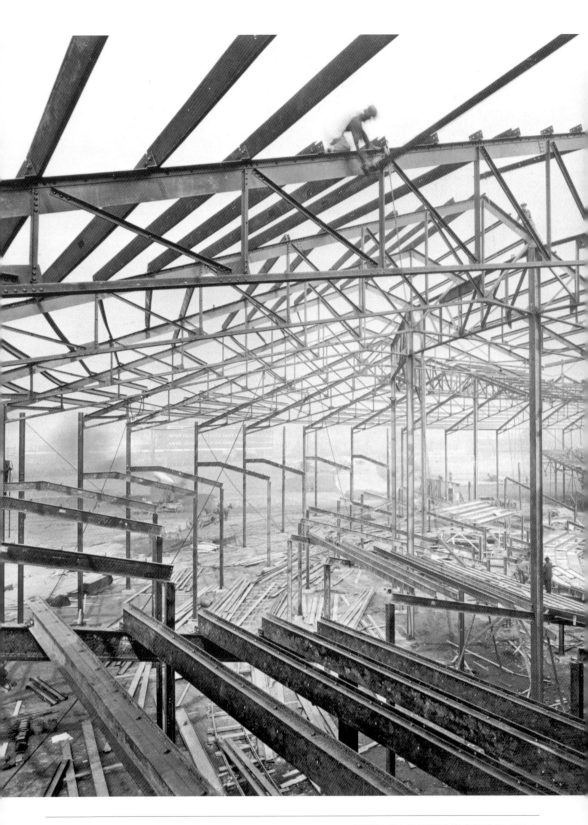

THE PARKWAY FIELD ERA

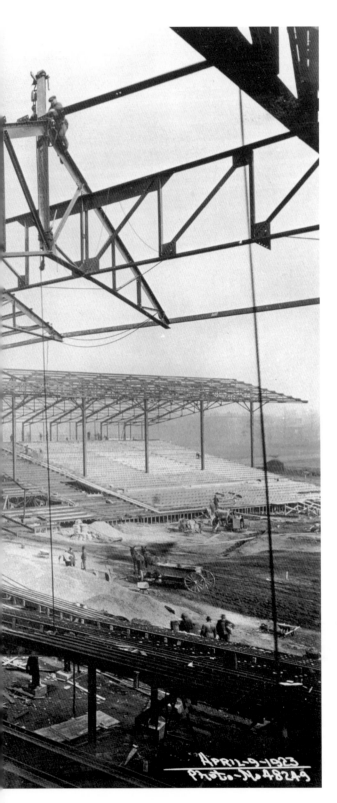

BUILD IT . . . Parkway Field takes shape with an impressive skeleton of steel. The stadium was built in just 63 days for approximately $250,000. Parkway Field got its name from Eastern Parkway, which had recently opened and ran along the left-field wall. The street, which runs from Cherokee Park to William Stansbury Park, actually had to be rerouted to make room for the diamond. (University of Louisville Photographic Archives.)

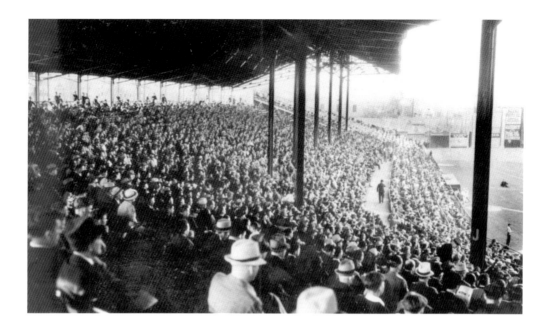

... AND THEY WILL COME. Here's a view down the same stretch of stands shown on the previous pages, now completed and packed with fans. Parkway's capacity was about 13,000. The ballpark opened on May 1, 1923. (University of Louisville Photographic Archives.)

NEAT SEATS. Note the shape of the Parkway Field seats in this photograph. Common by today's standards, the design was revolutionary when Parkway opened in 1923. Parkway Field was the first stadium built with seats that flipped up and down. They also had no front legs. Both of these patented features made postgame cleanup much more efficient. (University of Louisville Photographic Archives.)

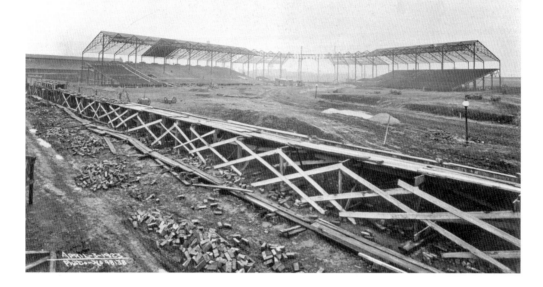

THE GREAT WALL. These two photographs show the construction and early days of the outfield wall at Parkway Field. In the top photograph, the wall takes shape in the foreground. The bottom photograph shows the completed wall as it looked in 1924. The outfield wall far outlasted the rest of the stadium. Part of the left-field wall was still standing along Eastern Parkway 80 years later, until it was deemed structurally unsound and torn down in 2004 as part of a renovation project by the University of Louisville. Bricks from the wall were incorporated into the university's new stadium. (University of Louisville Photographic Archives.)

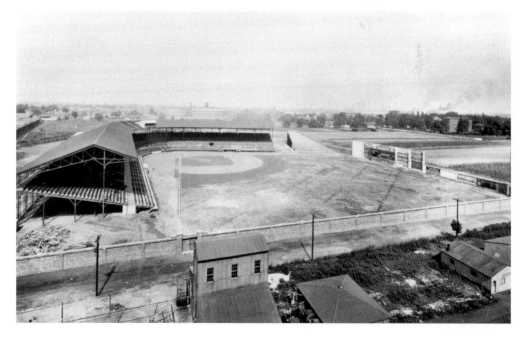

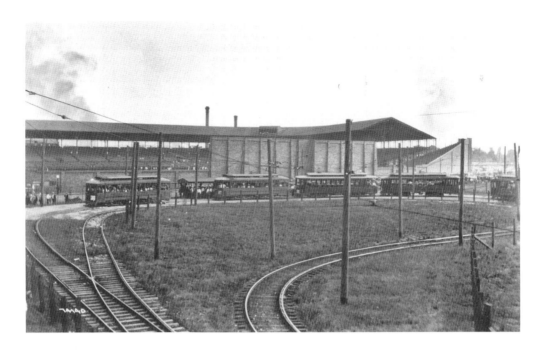

TROLLEY TRANSPORTATION. In 1926, trolleys line up around the loop near Parkway Field. (University of Louisville Photographic Archives.)

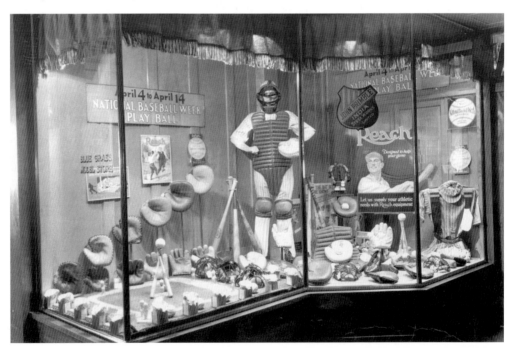

PLAY BALL! National Baseball Week provides the inspiration for this window display at a Belknap Hardware Store in 1924. (University of Louisville Photographic Archives.)

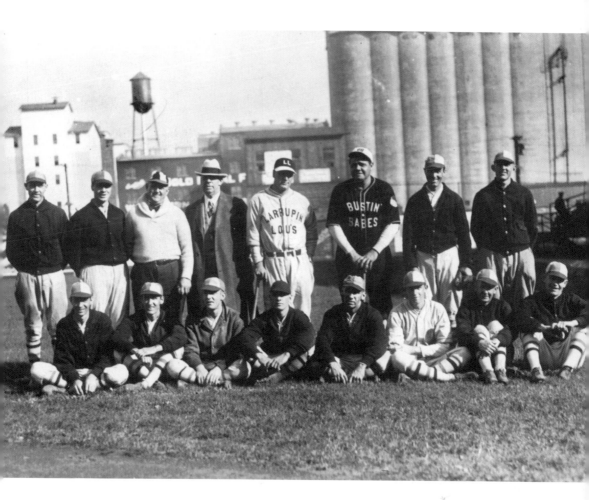

LOU AND BABE. The Larupin' Lou's, led by Lou Gehrig, and the Bustin' Babes, captained by Babe Ruth, played at Parkway on October 24, 1928. Both superstars played first base and then pitched the last inning of the game. Their "teams" were actually two leading local amateur teams. The game raised over $500 for Red Cross Florida Storm Relief. Ruth had two home runs, and Gehrig belted a grand slam. The Bustin' Babes came out on top, 13-12. Before the game, the two delighted the crowd with a batting bonanza that included two out-of-the-park smashes by Ruth, reported at the time to be the longest balls ever hit out of Parkway. Gehrig and Ruth are pictured here in their respective uniforms. (University of Louisville Photographic Archives.)

FLIP THE SWITCH. Lights were installed at Parkway Field in 1932. For the first time, night games could be played under permanent lights. The very first night game in Louisville actually took place at Parkway on September 14, 1931, when the traveling House of David team from Benton Harbor, Michigan, brought their own portable lighting system to town for a game against the Louisville All-Stars. The manager for the House of David was Hall of Famer Grover Cleveland Alexander. (University of Louisville Photographic Archives.)

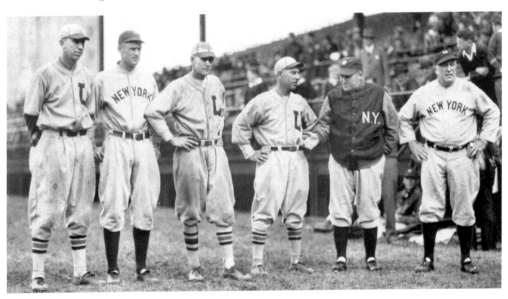

COLONELS V. YANKEES. On April 4, 1932, the New York Yankees stopped by Parkway Field for a preseason exhibition game against the Colonels. Even though their "Murderer's Row" batting lineup included Earle Combs (a former Colonel), Lou Gehrig, and Babe Ruth, the Colonels actually outhit New York; they also had more errors and lost the game 9-6. The first five men from the left all played together as Colonels between 1915 and 1925. They are John DeBerry, Earle Combs, Nick Cullop, Bruno Betzel, and Joe McCarthy. The sixth man is Jimmy Burke, who managed the Colonels in 1908. The Yankees went on the win the World Series in 1932, McCarthy's first year with the team. (University of Louisville Photographic Archives.)

THE PARKWAY FIELD ERA

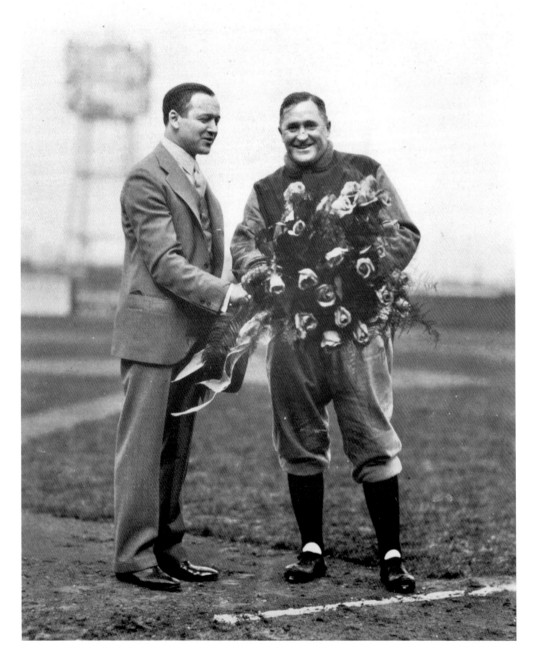

REAL MEN GET ROSES. Israel "Izzy" Goodman, a local business owner, presents Yankee manager Joe McCarthy with a big bunch of roses before the game. McCarthy jokingly indicated that he would've preferred a potted plant. The former Colonel skipper received a standing ovation from the crowd of 5,800. (University of Louisville Photographic Archives.)

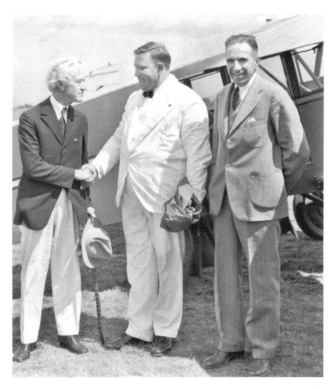

COMING IN FOR A LANDIS. Baseball's first commissioner, Kenesaw Mountain Landis (left), is greeted at Bowman Field by unidentified officials. This was probably taken in 1934, when Louisville hosted the National Association of Professional Baseball Leagues convention. Landis wielded powerful control as commissioner from 1920 until his death in 1944. He banned eight players from baseball after the Chicago Black Sox scandal of 1919 and implemented strong sanctions whenever he believed the integrity of baseball was being threatened. He entered the Hall of Fame in 1944. (University of Louisville Photographic Archives.)

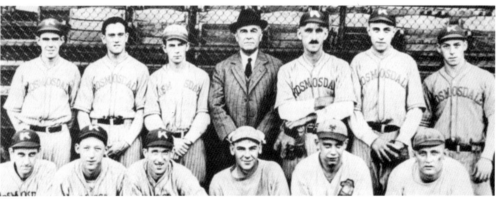

HONED IN ON HONUS. Louisville native Claude McFarlan knew Honus Wagner was star material and touted him to Louisville baseball officials with passionate determination. McFarlan played against Wagner in the minors and wanted his hometown team to sign him before anyone else did. Louisville officials believed Wagner was too bowlegged to play well, but in 1897, McFarlan's relentless campaign paid off when Wagner made his big-league debut with Louisville. McFarlan promoted baseball as a player and organizer. He is pictured here at Parkway with the Kosmosdale Independents. Louisville had an active amateur, semi-professional, and industrial team baseball scene for many years. From left to right are (first row) B. Yann, C. Medley, R. Thomas, E. Mayes, K. Higby, and F. McClain; (second row) H. Harbold, V. Franklin, H. Meyers, Claude McFarlan, G. Yann, H. Rummele, and S. Collings. (Bill McFarlan.)

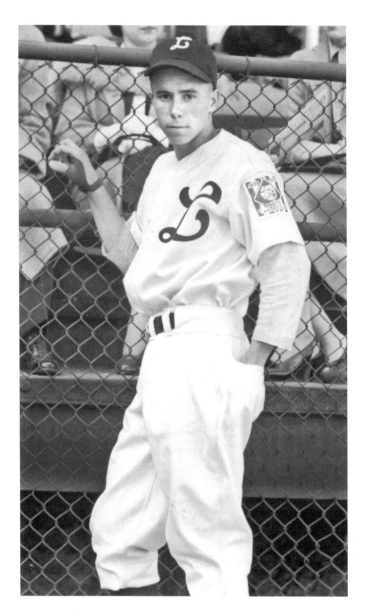

PEE WEE'S BIG DEBUT. Harold "Pee Wee" Reese was 19 years old when he signed a contract with Louisville in 1938 for $150 a month. He's shown here at his first Colonels game. In his second year with the team, Reese was selected for the All-Star Game. On his way there, a reporter told Reese that he had been sold to the Brooklyn Dodgers. He was allowed to play out the rest of the season with Louisville, which included winning the championship. At first, Reese was very disappointed about being sold, because he had hoped to play for the Boston Red Sox. He later said the deal to Brooklyn was "the greatest break of my life." He played in eight major-league All-Star Games and provided strong leadership as the captain of the Dodgers. He was elected to the Hall of Fame in 1984. Reese worked with Louisville Slugger after his retirement from professional baseball. (University of Louisville Photographic Archives.)

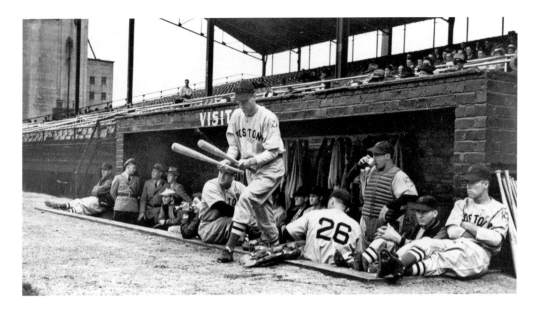

TAKE YOUR PICK. Ted Williams strides from the dugout with two bats during an exhibition game at Parkway in the spring of 1939, his rookie season. Player-manager Joe Cronin is seated below Williams's right arm, while Bobby Doerr is visible in the shadows over the shoulder of number 26. African American fans are seated in the bleachers on the far left side of the photograph. The stands at Parkway Field would remain segregated for another 17 seasons. (Louisville Slugger Museum & Factory Archives.)

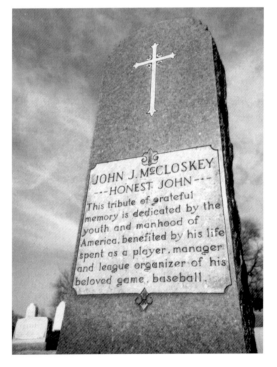

HONEST JOHN. In 1940, a tremendous force in the local and national baseball scene passed away. Chapter one recounted Louisville's very first professional team in 1876. Fourteen-year-old John McCloskey was their batboy. By the time he died at the age of 78, "Honest John" had managed a staggering 47 major- and minor-league teams and formed 10 leagues stretching from Louisville to Texas to the Pacific Northwest. Several of the leagues he created are still active today. His seven-foot-two-inch granite marker in Louisville's Calvary Cemetery refers to McCloskey's "beloved game, baseball." (Anne Jewell, Louisville Slugger Museum & Factory.)

THE PARKWAY FIELD ERA

DON'T LOOK BACK. Satchel Paige is shown here at Parkway Field. He came to town in 1941 for an exhibition game. At the time, he was still pitching with the Negro Leagues. Paige didn't get his shot at the majors until 1948, but he was already a legend when this photograph was taken. Joe DiMaggio called him "the best I've ever faced, and the fastest." Paige was inducted into the Hall of Fame in 1971. One of his many entertaining quotes about life was "Don't look back. Something might be gaining on you." He died June 8, 1982, just days before he was set to come to Louisville to work as a goodwill ambassador for the Louisville Redbirds. (Louisville Slugger Museum & Factory Archives.)

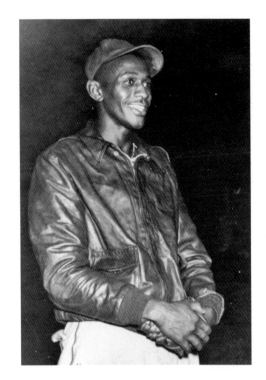

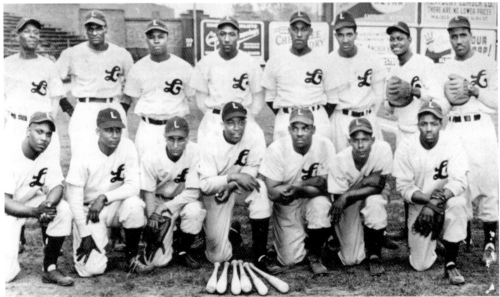

NEGRO LEAGUES AT PARKWAY. Louisville was home to several Negro League teams that used Parkway Field. They included the White Sox (Negro National League, 1931), Black Caps (Negro Southern League, 1932), and Buckeyes (Negro American League, 1949). The team in this photograph taken at Parkway is unidentified. (University of Louisville Photographic Archives.)

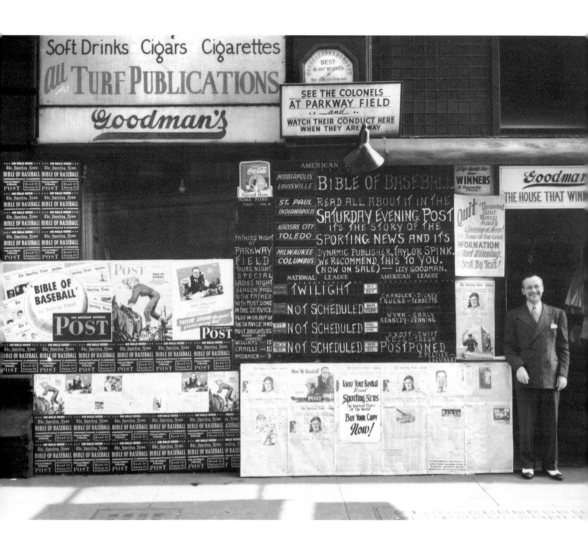

YOU HEARD IT HERE FIRST. Israel "Izzy" Goodman flashes a grin in the doorway of Goodman's News Service at 332 West Liberty Street. This photograph was taken in 1942. In the middle of the shot, handwritten on the chalkboard beneath the headline "Fathers' Night at Parkway Field," season passes are being offered to fathers with sons and daughters in the service. Goodman is the same man who memorably presented Joe McCarthy with a load of roses 10 years earlier. (University of Louisville Photographic Archives.)

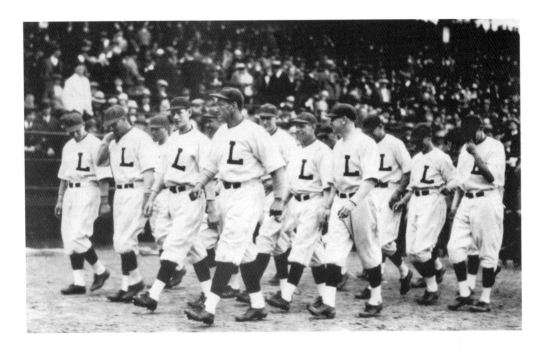

GIMME AN "L"! The Louisville Colonels of 1942 stride en masse along the diamond at Parkway Field. (University of Louisville Photographic Archives.)

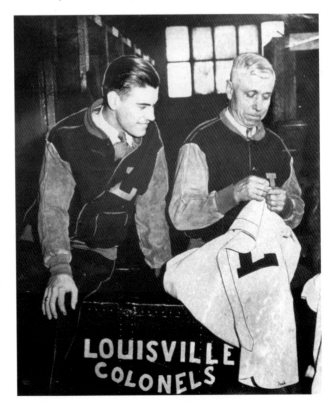

UNIFORM CHECK. Henry "Hump" Pearce (right) looks over a player's uniform in the Colonels' clubhouse. Pearce was the trainer for the team from 1932 to 1942. (University of Louisville Photographic Archives.)

BOYS AND BOBBY SOXERS. Young fans wait in line to quench their thirst, while some nearby girls try to stay cool in the shade and their summer dresses. (University of Louisville Photographic Archives.)

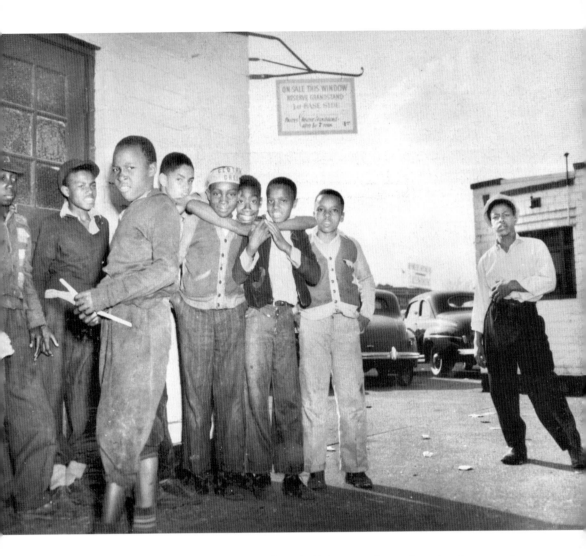

STILL SEGREGATED. A group of boys pose outside of Parkway on April 16, 1942. When this photograph was taken, the ballpark's stands were still segregated. That changed in 1956. A Cuban syndicate bought the team from the Red Sox, and the stadium was desegregated that season. (University of Louisville Photographic Archives.)

PATRIOTIC PITCH. Draped in bunting, this building at 307 West Walnut bids men and women to come in for batting practice in 1943. A smaller sign above the door refers to "base ball" as "America's Greatest Indoor Court Game." Indoor baseball started in Chicago and was played with a larger ball. While the game was a forerunner of today's softball, the indoor version of baseball had mostly disappeared when this photograph was taken. (University of Louisville Photographic Archives.)

ROOTIN' FOR THE COLONELS. By the time Parkway Field opened, Louisville baseball fans had come a long way in their knowledge of the game. While many in attendance at Louisville's first official game in 1865 were not familiar with baseball, the rapt attention of these fans indicates a keen interest in what's happening on the diamond. (Louisville Slugger Museum & Factory Archives.)

THE PARKWAY FIELD ERA

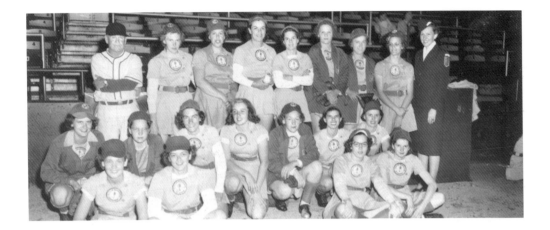

ATTA GIRL! The Muskegon Lassies of the All-American Girls Professional Baseball League (AAGPBL) are pictured here at Parkway Field in 1949. They were in town for a couple of double headers with the Grand Rapids Chicks, Racine Belles, and Kenosha Comets. The AAGPBL was formed during World War II to substitute for the lack of minor-league teams and to boost morale. The gals were required to attend charm school, and each team had a chaperone. Thanks to their ladylike, skirted uniforms, the athletes endured some tough abrasions on their legs. The league lasted through 1954, longer than many people expected. From left to right are (first row) T. Fisher, D. Tetzlaff, B. Allard, and S. Burkovich; (second row) M. Kruckel, B. Francis, B. Wegman, M. Meacham, D. Barr, S. Lonetto, and D. Stolze; (third row) manager C. Bigbee, N. Arnold, J. Gutz, M. Chapman, C. Pryer, A. Applegren, J. Lenard, D. Sams, and chaperone H. Hannah. (University of Louisville Photographic Archives.)

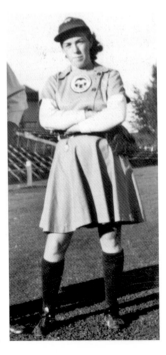

"LEFTY" FROM LOUISVILLE. The AAGPBL recruited players from various cities, including Louisville. Tryouts were held at Parkway Field. One Louisvillian to play for the AAGPBL was Gertrude "Lefty" Ganote. She played first base and pitched occasionally for the Kenosha Comets in 1944 and the South Bend Blue Sox in 1945. Her solid play at first earned her top defensive honors at that position in 1944. (Linda Weise Adams.)

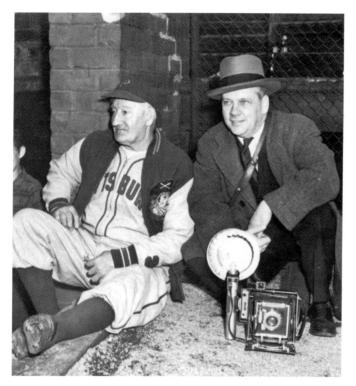

YESIREE, THOSE WERE THE DAYS. Seventy-year-old Honus Wagner returned to Louisville with the Pirates in 1944. He makes himself at home on the edge of Parkway's dugout with R. G. Potter, who collected many of the shots in this volume. During this visit, Wagner recalled his playing days here in the late 1890s, "There never was a town like Louisville for being rough on the umpire. I remember when the bleachers didn't like a decision, men would get out their guns and shoot up into the air." (University of Louisville Photographic Archives.)

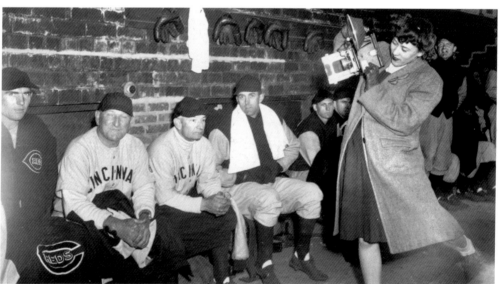

YOU GO, GIRL. Martha Holmes, identified on the back of this picture as "girl photographer," lines up her shot at Parkway in 1944. She went on to join the staff at *Life* magazine, where her shots of painter Jackson Pollock were the first images published of the controversial artist. Her work has been exhibited at the National Portrait Gallery and the Louvre in Paris—not bad for a "girl photographer" from Louisville. (University of Louisville Photographic Archives.)

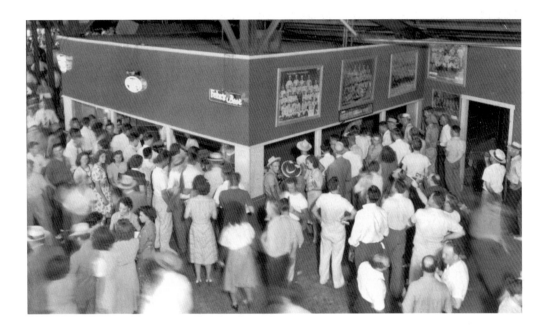

WHO'S NEXT? Fans flock to the refreshment stand at Parkway Field. Attendance for minor-league games remained strong until the 1950s, when television and air-conditioning made baseball an enjoyable pastime indoors. (University of Louisville Photographic Archives.)

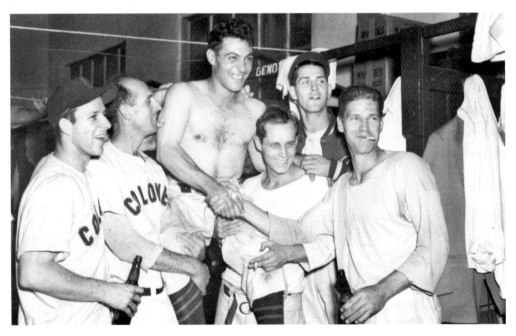

THIS'LL PUT HAIR ON YOUR CHEST. Happy Colonels celebrate in their clubhouse with smokes and beers. Cigarettes and alcohol seem like old-fashioned vices compared to today's allegations of steroid use in baseball. (University of Louisville Photographic Archives.)

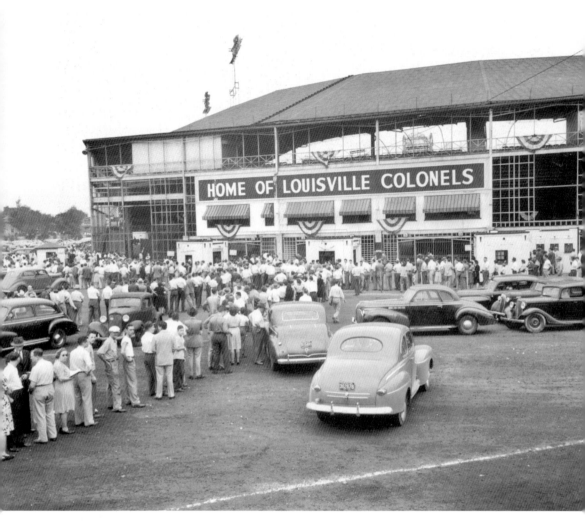

HOME OF LOUISVILLE COLONELS

JUNIOR WORLD SERIES. Louisville fans line up for tickets to the 1945 Junior World Series, which the Colonels won over Newark four games to two. A similar scene would occur the following year, when Louisville made a repeat trip to the minor-league championship series. But in 1946, Jackie Robinson was playing second base for the visiting Montreal Royals. A limited number of African Americans were allowed into Parkway for the games, prompting this comment in a *Courier-Journal* editorial: "This policy has contributed to a weakening of community relationships . . . it was not an ordinary series for Louisville, because of Robinson's presence . . . it was a test of sportsmanship all around such as we never had here before. Certainly it was no time to apply discriminations and restrictions so self-conscious and arbitrary." (University of Louisville Photographic Archives.)

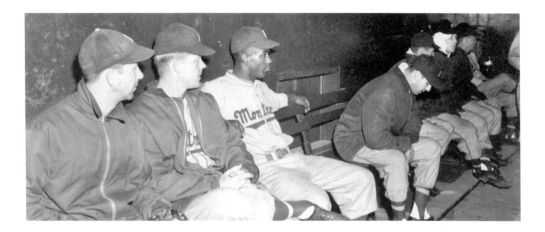

JACKIE ROBINSON COMES TO TOWN. In September 1946, Jackie Robinson arrived in Louisville with the Montreal Royals for the Junior World Series. He is shown here in the dugout at Parkway Field. Years later, in his autobiography, Robinson recalled his reception by Louisville fans: "I had been booed pretty soundly before, but nothing like this. A torrent of mass hatred burst from the stands with every move I made." Robinson batted .400 in the series as his Royals defeated the Colonels four games to two in the championship. The next year, Robinson made his major-league debut with the Brooklyn Dodgers as the first African American to break the color barrier in modern-day major-league baseball. He was inducted into the Hall of Fame in 1962. (University of Louisville Photographic Archives.)

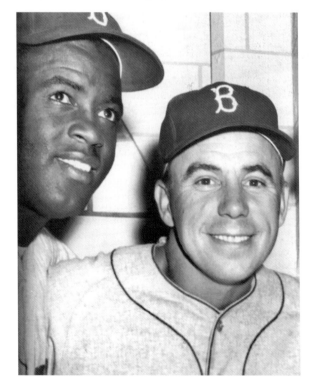

UNITED WE STAND. Louisville native and former Colonel Pee Wee Reese was captain of the Brooklyn Dodgers when Jackie Robinson joined the team in 1947. Reese demonstrated unparalleled leadership in his support of Robinson during this controversial, volatile, and groundbreaking time. In one famous incident, Reese sent a powerful message to Robinson's vitriolic detractors when he walked across the diamond to stand beside his teammate in an unforgettable demonstration of solidarity. When Reese casually draped his arm on Robinson's shoulders, it was a genuine nonverbal gesture that spoke volumes. (The Reese family.)

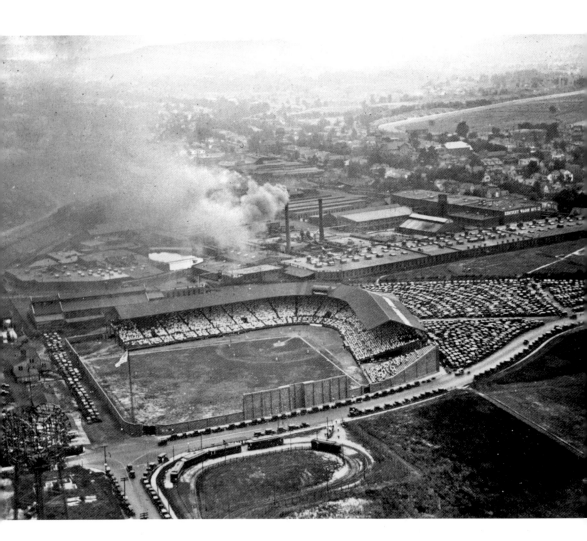

MOVING ON FROM PARKWAY. The Colonels played their last game at Parkway Field in 1956. Their affiliation with the Red Sox had come to an end, and the team was now privately owned by a group of Cubans. A new, larger stadium at the nearby Kentucky State Fairgrounds was ready for them. The University of Louisville, which now owned Parkway, used the field for their baseball team until 1996. Eastern Parkway runs along the bottom of this aerial shot, which provides a good view of the portion of Parkway's left-field wall that remained standing until 2004. The horizon in this photograph is the general direction of the Fairgrounds and, eventually, Louisville International Airport. (University of Louisville Photographic Archives.)

THE PARKWAY FIELD ERA

FAIRGROUNDS STADIUM, GOODBYE FOR NOW

1957–1972

They had a sparkling new stadium in 1957, but the Colonels struggled financially. Attendance for minor-league baseball had been dropping throughout the 1950s. In the last couple of years at Parkway Field, annual attendance had dipped as low as 134,000. The Cuban syndicate that purchased the team with the intention of running it as a profitable business went bankrupt not long after the deal was done.

Other challenges presented themselves during this era. After the Red Sox partnership ended in 1956, the Colonels limped along without a major-league affiliation for several seasons, until they teamed up with the Milwaukee Braves in 1959. That union lasted through 1962, but then the American Association folded, ending a 61-year minor-league run with Louisville. Since the beginning of that relationship in 1902, seven future Hall of Famers had played for or managed the Colonels: Joe McCarthy, Earle Combs, Billy Herman, Burleigh Grimes, Pee Wee Reese, Max Carey, and Phil Niekro. But the league was no more, and the city went without a team for five seasons. In 1964, the owner of the Kansas City Athletics was interested in moving his major-league team to Louisville, but American League owners stopped the deal. When minor-league baseball returned to Louisville in 1968, it was with the International League, but that lasted only five seasons.

During this era, the game played on despite the trials endured. And there were bright spots, including pennants and future major-league stars in the lineup.

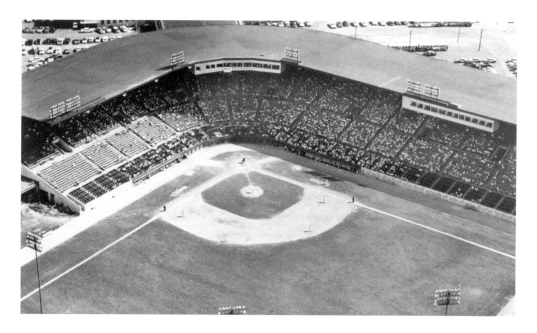

NEW HOME OF THE COLONELS. Fairgrounds Stadium was built as part of the new $16-million Kentucky State Fairgrounds complex. It also hosted non-sporting events like concerts and rallies. Note the two press boxes: one behind home plate for baseball, the other along the third-base line for football. (*The Courier-Journal.*)

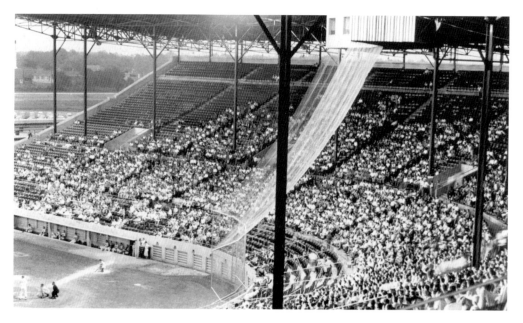

FIRST SEASON AT THE FAIRGROUNDS. Almost 6,500 fans came to this game on June 4, 1957. It was the biggest turnout since the inaugural opening night at Fairgrounds Stadium a couple of months earlier. (*The Courier-Journal.*)

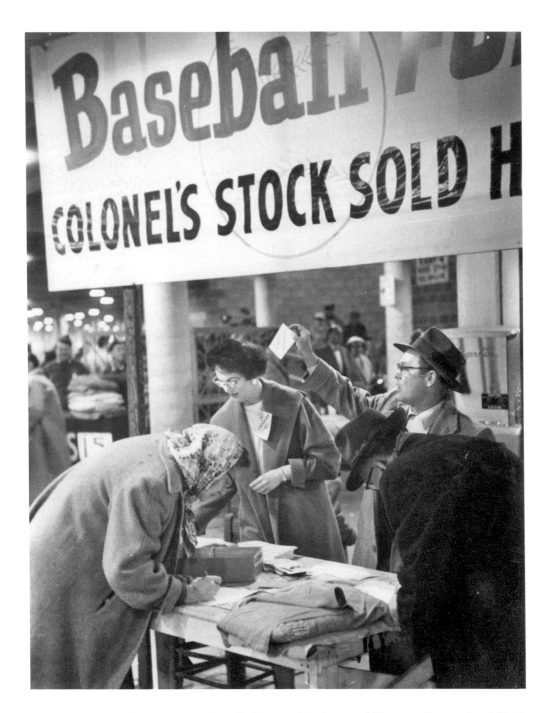

THE COMMUNITY TAKES STOCK. Even before their move to the Fairgrounds, the Colonels were experiencing financial troubles. The Cuban ownership went bankrupt, and the team became a community-owned operation in 1957, selling 2,800 shares at $10 apiece. During this difficult financial time, the team was charged no rent for Fairgrounds Stadium, while they survived with no major-league affiliation. (University of Louisville Photographic Archives.)

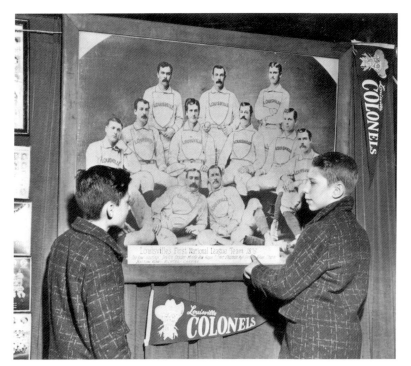

"CHECK THIS OUT, RONNIE." During the 1958 Mid-America Sports Show, Ronnie (left) and Jerry Harris explore a booth at the Fairgrounds featuring a large photograph of Louisville's first major-league team. (*The Courier-Journal.*)

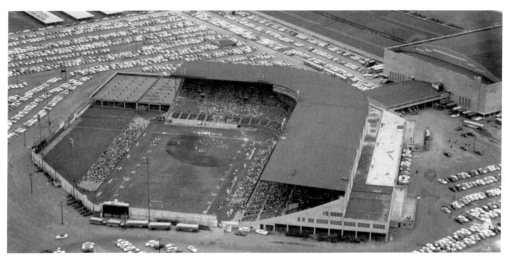

FOOTBALL WILL COME TO PASS. This overhead shot of Fairgrounds Stadium on September 21, 1958, shows a professional football exhibition game being played on the baseball diamond. It foreshadows the future eviction of the Colonels' baseball operation from the stadium. The temporary stands in right field became a permanent fixture after the 1972 season, when the stadium was converted for University of Louisville football games. The Colonels could no longer play there, so they left town. This game featured the Baltimore Colts with former University of Louisville stars Johnny Unitas and Lennie Lyles. (University of Louisville Photographic Archives.)

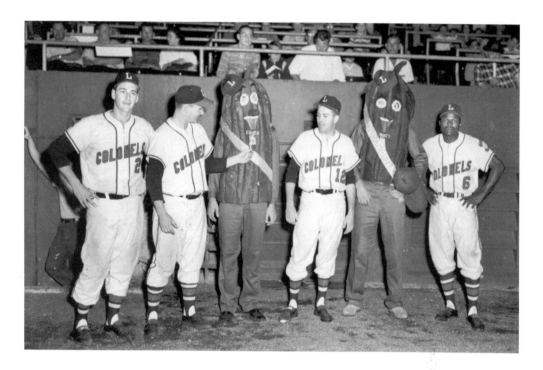

WE'RE IN A PICKLE. A pair of Paramount pickles pose with some members of the Louisville Colonels in 1959, eliciting mixed reactions from the players. At least they went on to win the pennant that year. (University of Louisville Photographic Archives.)

ANOTHER FUTURE YANKEE SKIPPER. Joe Torre was just 19 years old when this photo was taken in 1960. Torre joined the Louisville Colonels the following year. In his 27 games with Louisville, he batted .342. He was called up to the Milwaukee Braves and wrapped up 18 seasons in the majors with a .297 batting average. Like Joe McCarthy, this former Colonel went on to manage in the big leagues with great success. He has been with the New York Yankees since 1996 and has won four World Series there. (Associated Press/Wide World Photos.)

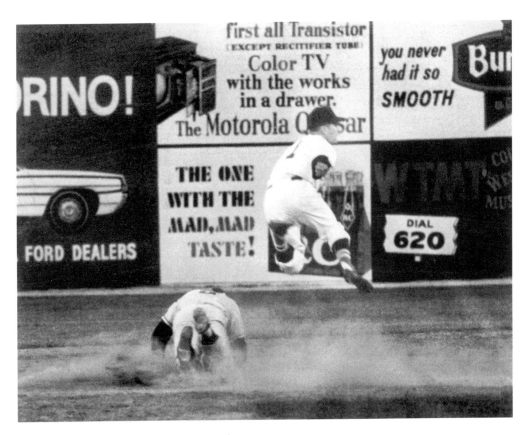

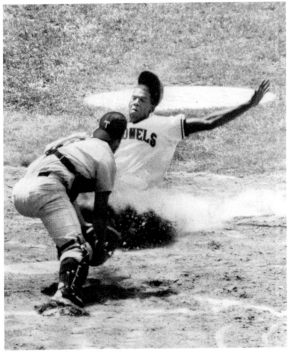

MAD, MAD, TASTE! Louisville went five seasons without a team after the American Association folded in 1963. Minor-league action resumed with the International League in 1968. This shot from that year shows Colonels shortstop Al Lehrer leaping above a Rochester player sliding into second. Lehrer completed the double play, but the game was the Colonels' first loss at home that season. (*The Courier-Journal.*)

OUT! Bobby Mitchell is tagged out at home on this attempt, but Mitchell did later score the game's only run to secure the 1-0 victory for the Colonels in this 1968 game. (*The Courier-Journal.*)

SCOREBOARD VIEW. Al Yates catches the first out in right field during this playoff game against Syracuse on September 4, 1969. This photograph was taken from the scoreboard. Louisville won this game 4-0 but ended up losing the playoffs to Syracuse. (*The Courier-Journal.*)

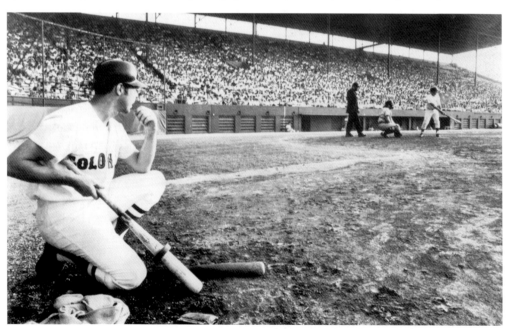

WHO'S ON DECK? Ed Phillips waits his turn at bat as Don Fazio gets ready for the next pitch. Louisville lost 4-0 to Syracuse in this game on July 12, 1970, but 15,301 fans turned out to cheer them on. (*The Courier-Journal.*)

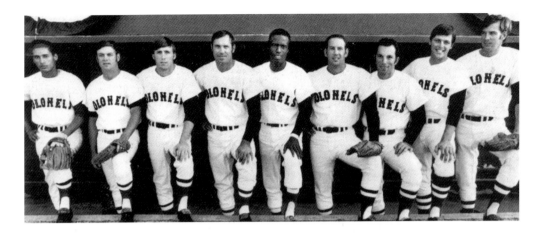

FISK AND FRIENDS. Here's the 1971 opening day lineup. Carlton Fisk is second from the right. The 23-year-old catcher batted .263 in his 94 games with the Colonels. He went on to a legendary 24-year career in the majors, including 11 All-Star appearances. Fisk provided baseball with one of its most enduring iconic moments during the 1975 World Series, when he practically willed his home run shot to stay in fair territory by fervently waving his arms as he watched the flight of the ball on his way down the first-base line. The ball hit the left field pole, winning the game for the Red Sox in the 12th inning. Fisk was inducted into the Hall of Fame in 2000. Each of these Colonels played in the majors, with big-league careers ranging from 12 games to 24 years. From left to right are J. Beniquez, B. Hunter, R. Miller, H. Taylor, B. Ogilvie, M. Derrick, C. Coletta, Fisk, and J. Lonborg (Cy Young Award Winner, 1967). (*The Courier-Journal.*)

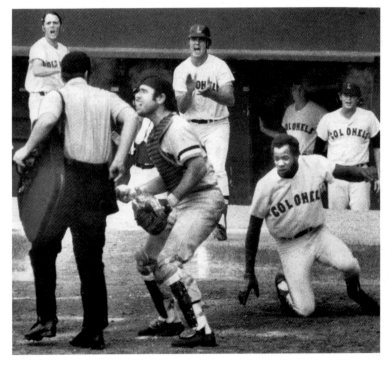

INSIDE-THE-PARK HOME RUN. Cecil Cooper (right) just beat the throw to the plate . . . or did he? Charleston's catcher argues, while Colonels taunt him and applaud Cooper's rare feat in 1972. That year, Cooper played 134 games with Louisville and batted .315. The first baseman had a 16-year career in the big leagues, with five All-Star appearances and a .297 average. (*The Courier-Journal.*)

FAIRGROUNDS STADIUM

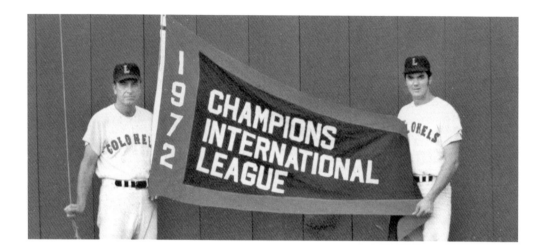

HOIST IT HIGH. The Colonels won the International League pennant in 1972 by a one-game margin on the last day of the season. Dwight Evans (right) and manager Darrell Johnson show off the banner. Evans was the International League's MVP that year, batting .300 with 17 home runs, including the game-winning home run that captured the pennant. The talented outfielder went on to a 20-year major-league career and won eight Gold Gloves with the Boston Red Sox. He also appeared in three All-Star Games. Darrell Johnson managed in the majors for eight years. (Louisville Slugger Museum & Factory Archives.)

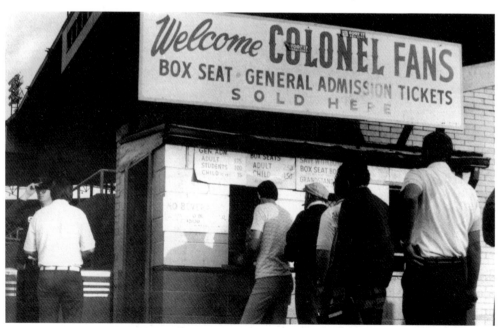

ONE, PLEASE. The ticket booth at Fairgrounds Stadium takes care of a few fans before a playoff game in 1972. Even with the Colonels' tight pennant race and postseason play, not many people were coming to the games. (*The Courier-Journal.*)

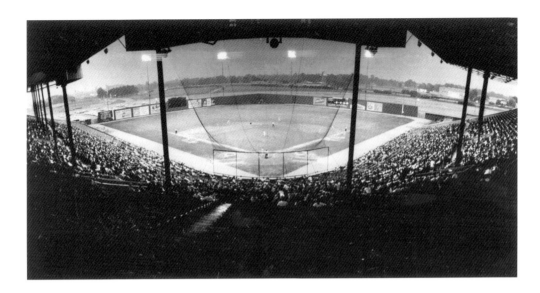

FAREWELL, FOR NOW. This shot was taken on September 12, 1972—the Colonels' last game at Fairgrounds Stadium, a postseason playoff against Tidewater. Only 3,500 fans turned out for the finale, which the Colonels lost 6-3. Even as the last out was called, the team was hoping it could still play ball at the Fairgrounds the next year. (*The Courier-Journal.*)

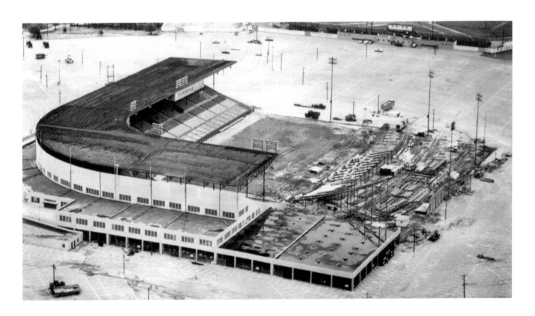

CONSTRUCTION KICKS OFF. This shot from May 1973 shows the ballpark being converted to a football stadium for the University of Louisville. Stands were plunked down in right field, increasing capacity to 38,000. With no place to play, the Colonels moved to Pawtucket, Rhode Island, and became the Pawtucket Paw Sox. Nearly a decade would go by before professional baseball returned to Louisville. (*The Courier-Journal.*)

FAIRGROUNDS STADIUM

BASEBALL IS BACK IN A BIG WAY

1982–PRESENT

What does Springfield, Illinois, have to do with baseball in Louisville? That's where Louisville found the Redbirds, a team that tapped into the town's long-running love of baseball with wildly successful results.

After nine seasons without professional ball, Louisville got back in the game. Community leaders wooed and won over the owner of the Springfield Redbirds, the Triple-A farm team for the St. Louis Cardinals.

And so began the newest era in Louisville's bond with baseball. In keeping with the impressive heritage that came before it, Louisville's latest chapter of baseball history is being written with colorful characters, memorable moments, and many loyal fans.

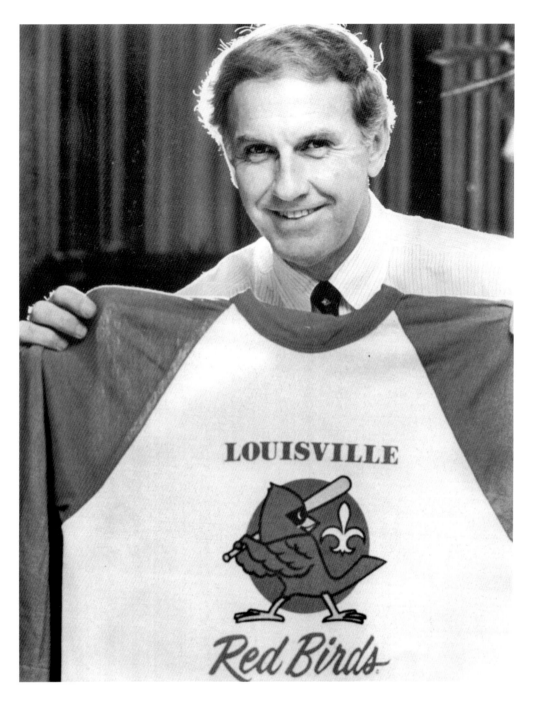

LOUISVILLE LEADER. During the major-league player strike of 1981, Dan Ulmer decided it was time for professional baseball to return to Louisville, so he led the effort to make it happen. At the time, he was president of Citizens Fidelity Bank. Ulmer cochaired the Louisville Baseball Committee and raised over $4 million to move the football stands out of right field in what would soon be called Cardinal Stadium. (*The Courier-Journal.*)

BASEBALL IS BACK IN A BIG WAY

ANOTHER TEAM PLAYER. Former Jefferson County judge-executive Armin Wellig was the head of Dixie Beer Distributors when he cochaired the Louisville Baseball Committee with Dan Ulmer. They searched for a team in the Triple-A American Association, which had been resurrected in 1969. On October 5, 1981, he and Ulmer announced a minor-league team was coming to Louisville, and they introduced the team's owner, A. Ray Smith. (*The Courier-Journal.*)

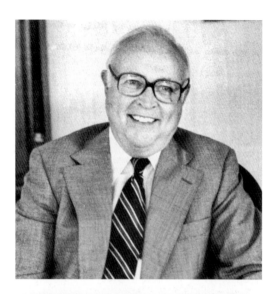

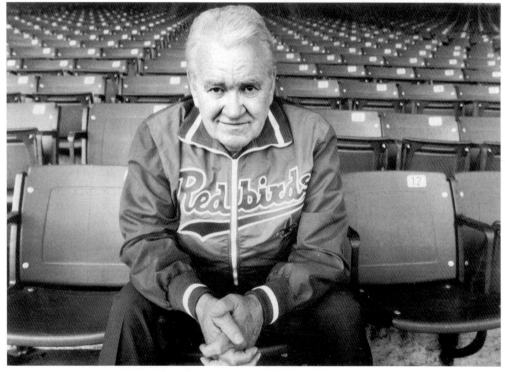

A. RAY IS A-OK. Meet the man who moved his team to Louisville. A. Ray Smith had owned the Redbirds (the St. Louis Cardinals' top farm team) since 1969. He was not satisfied with their location in Springfield, Illinois, and made the jump to Louisville with gusto. He brought his philosophy that baseball should be an affordable family outing with low ticket prices, tasty concessions, and a clean park. Smith payed his players and management more than other teams at the time. They also received more meal money and stayed at better hotels. (*The Courier-Journal.*)

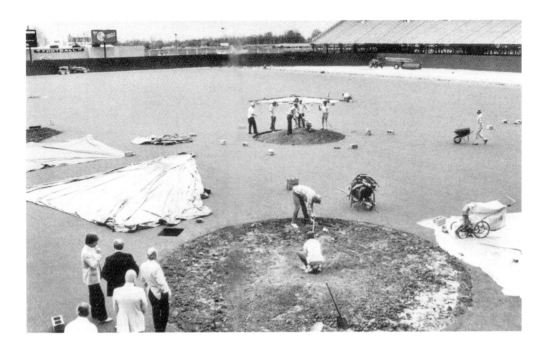

A Diamond in the Rough. Getting the field game-ready required some round-the-clock work as opening day drew near. This shot was taken the day before the first game. Football would still be played here, but the stands (visible in the upper right corner) were moved further back in right field. (*The Courier-Journal.*)

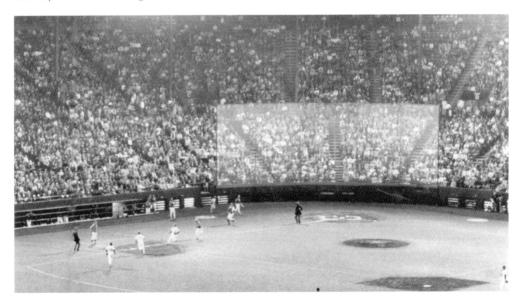

April 17, 1982. Professional baseball is back in Louisville! The Redbirds lost to the Iowa Cubs, 7-4, but that hardly dampened the enthusiasm of the whopping 19,632 fans in attendance. (*The Courier-Journal.*)

BASEBALL IS BACK IN A BIG WAY

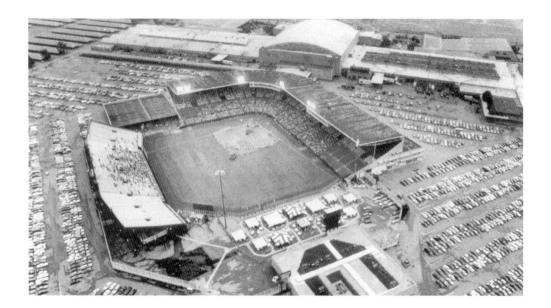

HOME OF RECORD-SETTING CROWDS. How much did Louisville want baseball back? In the first year, the city demolished the season attendance record set by the San Francisco Seals in 1946. That long-standing mark had been 670,563. In 1982, the Redbirds saw 868,418 fans pass through their turnstiles! Team owner A. Ray Smith invested $750,000 in additional stadium improvements for the next season, which would prove to be another record-setter in a big, big way. (*The Courier-Journal.*)

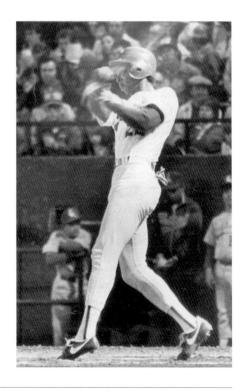

ST. LOUIS, HERE I COME. Willie McGee smacks a double for the Redbirds. He played 13 games in 1982 before being called up to the Cardinals, who went on to win the World Series that year. In his 17 years with the big leagues, McGee batted .293 and played in four All-Star Games. (*The Courier-Journal.*)

BASEBALL IN LOUISVILLE

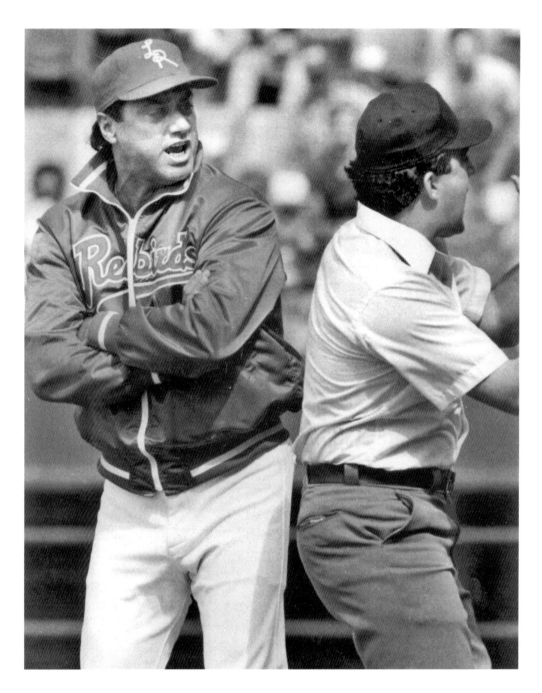

RUFFLED FEATHERS. Jim Fregosi was ejected four times during his first season as manager of the Redbirds in 1983. He was named American Association Manager of the Year in 1983 and 1985. His colorful, commanding style ignited even more excitement for the program. Fregosi was a six-time All-Star shortstop during his 18 years in the majors and had managed the California Angels. He left the Redbirds during the 1986 season to manage the Chicago White Sox. (*The Courier-Journal.*)

BASEBALL IS BACK IN A BIG WAY

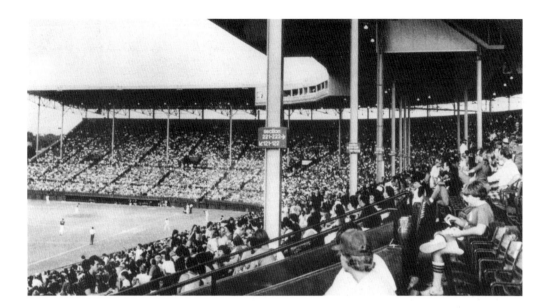

1,052,438! That's how many people came to see the Redbirds play at Cardinal Stadium during the regular season in 1983. Hitting the 1-million mark for the first time in minor-league history was a stunning achievement and one that A. Ray Smith actually predicted would happen at the start of the season. Add in the attendance for their postseason play, and the grand total was 1,091,390. (*The Courier-Journal.*)

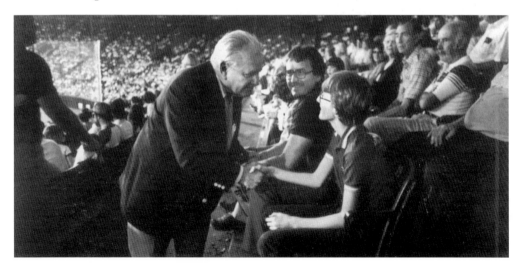

KEEPIN' THE FANS HAPPY. A. Ray Smith made a habit of walking through the crowd at home games. During his rounds, he gathered feedback and suggestions from fans. He must have been doing something right. The year the Redbirds topped a million fans, they outdrew three major-league teams and averaged more fans per home game than five teams in the majors, including nearby Cincinnati. Smith sold the team in 1986 to a group of local businessmen, which included Dan Ulmer. (*The Courier-Journal.*)

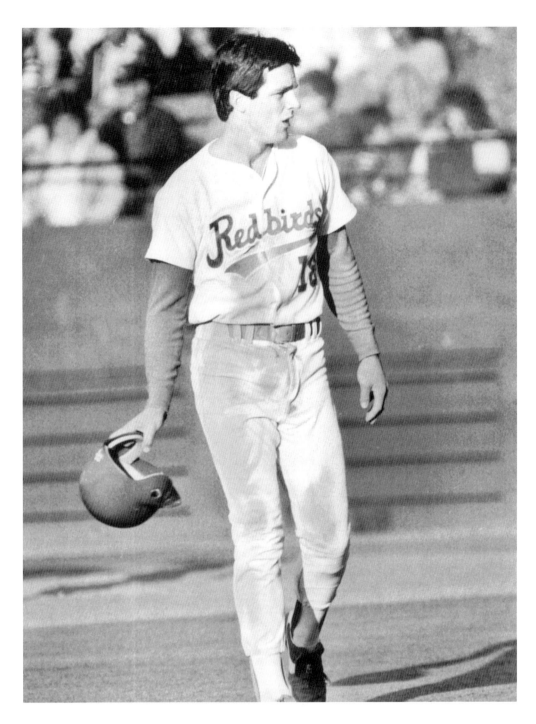

ON HIS WAY UP. Andy Van Slyke played with the Redbirds for 54 games in 1983. He's shown here after scoring in a match-up against the Denver Bears. Van Slyke batted .368 for Louisville before moving up to the Cardinals. In his 12 major-league years, he was a three-time All-Star and batted .274. (*The Courier-Journal.*)

BASEBALL IS BACK IN A BIG WAY

BOUND FOR THE BIG LEAGUES. Terry Pendleton played 91 games with the Redbirds in 1984 and was batting .297 when the Cardinals called. The third baseman played in one All-Star Game during his 15 years in the big leagues and batted .270. (*The Courier-Journal.*)

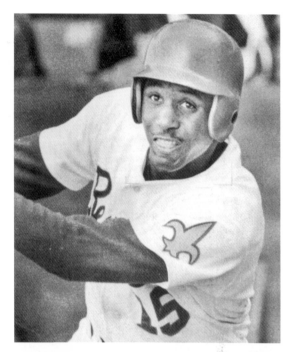

ROUGH AND TUMBLE. A Buffalo player tries to break up the double play, but Redbirds second baseman Joe Pettini appears to levitate above the Bison as he completes the play to first. Pettini also went three-for-three in this 1985 game. He later managed the Louisville franchise from 1994 to 1996 and is currently the bench coach for the St. Louis Cardinals. (*The Courier-Journal.*)

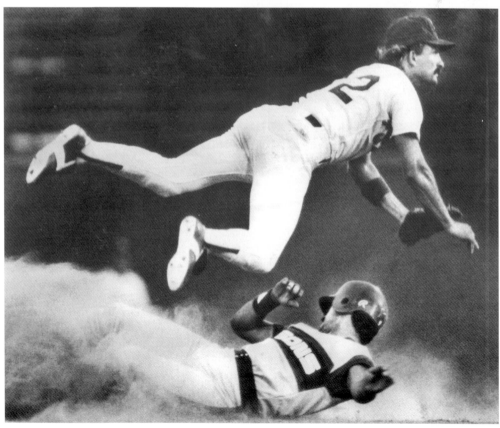

NICE CLEATS. Todd Worrell, the pitcher of "pink cleats" fame described in the foreword, high-fives catcher Randy Hunt after fanning five hitters in the last two innings of a victory in 1985. Worrell played 11 years in the majors with the Cardinals and Dodgers. (*The Courier-Journal.*)

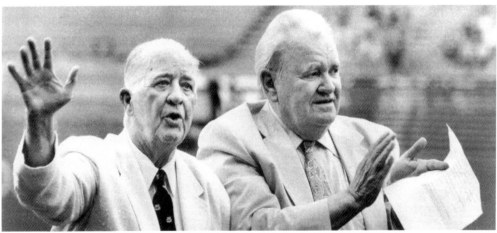

HAPPY, RAY ARE HERE AGAIN. On July 3, 1987, Albert "Happy" Chandler (left) joined A. Ray Smith at a Louisville Redbirds game. Chandler had been the governor of Kentucky and a U.S. senator before he succeeded baseball's first commissioner, the omnipotent Judge Kenesaw Landis. As commissioner from 1945 to 1951, Chandler helped open the major leagues to African Americans by supporting the signing of Jackie Robinson, even though team owners voted against it 15-1. Other clashes with some owners led to Chandler only serving one term. The owners voted 9-7 to keep him, but re-election required 12 votes. Chandler quipped, "It was the only election I ever lost where I got the majority of the votes." He entered the Hall of Fame in 1982. (*The Courier-Journal.*)

HERE'S THE PITCH. Louisville's Todd Zeile prepares for the pitch during the minor-league All-Star Game in 1989. That year, he played 118 games with the Redbirds and batted .289. (Associated Press/Wide World Photos.)

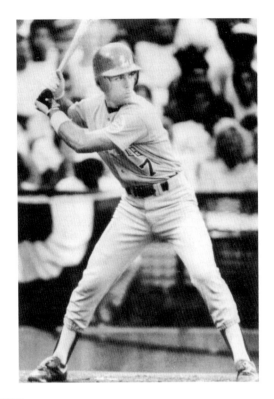

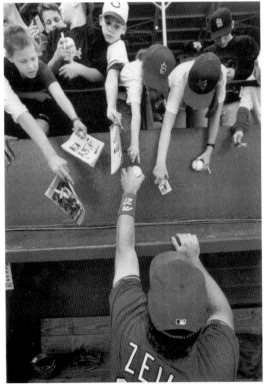

SIGN AND STRETCH. After making the jump to the majors, former Redbird Todd Zeile signs autographs for fans at Cardinal Stadium. Zeile was in town with St. Louis for an exhibition game against the Reds in 1994. He batted .265 in his 16-year major-league career. (*The Courier-Journal.*)

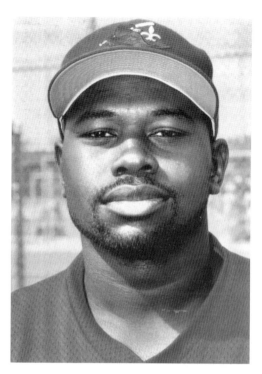

STILL SWINGIN'. Dmitri Young donned a Redbirds uniform for 122 games in 1996 and batted .333. So far, he is batting .291 in the majors and has played in one All-Star Game in his 10 years with the big leagues. (*The Courier-Journal.*)

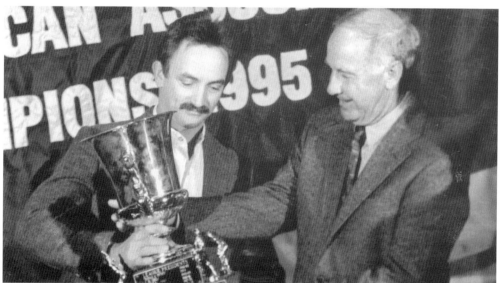

SURPRISE CHAMPS. After starting the season strong and then reeling from the loss of players to Cardinal call-ups, the Louisville Redbirds surprised everyone in 1995 when they made a run at the championship, beating out Indianapolis and Buffalo for the title. Manager and former Redbird player Joe Pettini (left) and owner Dan Ulmer happily hold the American Association championship trophy. After the 1997 season, the American Association folded again, and Louisville joined the International League, where they remain today. (*The Courier-Journal.*)

HEY BUDDY, CAN YOU SPARE A BAT? In 1998, the Cardinals and Redbirds parted ways after a 16-year relationship, and Louisville aligned with the Milwaukee Brewers. In anticipation of a new downtown stadium near the Ohio River, the team changed its name to the RiverBats, which was shortened several seasons later to the Bats. When they moved into Louisville Slugger Field in 2000, they did so with a new major-league affiliate, the Cincinnati Reds. Buddy Bat appears unfazed by the flurry of changes. (Louisville Bats.)

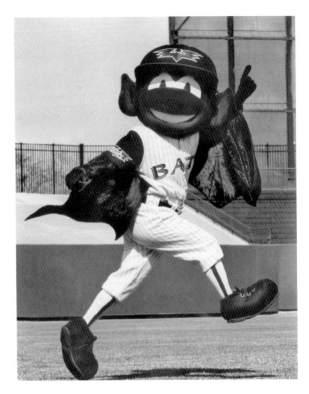

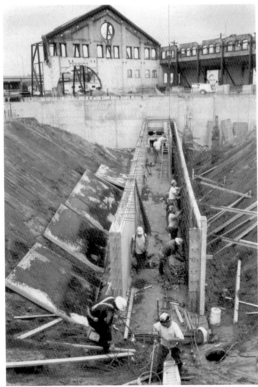

DIGGING NEAR THE DUGOUT. On November 13, 1998, officials broke ground on the new stadium, Louisville Slugger Field. Located downtown, near the Ohio River, the park mixed historic architectural elements with the latest in baseball park amenities, including a children's play area and private suites. The visiting team's tunnel to the dugout is shown under construction here. At the top of the photograph is part of the historic train depot that was integrated into the design of the $39-million project. The train shed dates back to the early 20th century, the same time the Louisville Colonels started their 61-year run with the minor-league American Association. (*The Courier-Journal.*)

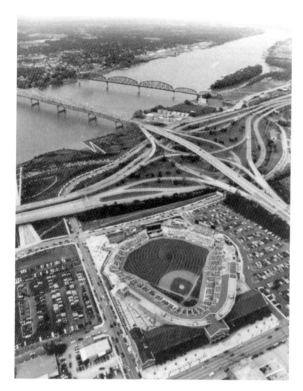

THE BEST-NAMED BALLPARK IN AMERICA. Louisville Slugger Field opened in April 2000. Located on East Main Street and nestled near the tangled highway system affectionately known as "Spaghetti Junction," the sparkling diamond hosts over 600,000 guests a year for games and other events. (Louisville Bats.)

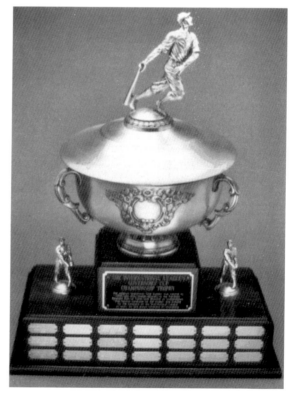

GOVERNORS' CUP. Louisville set a franchise record with 84 wins in 2001. They beat Scranton/Wilkes-Barre in the first game of the Governors' Cup Championship. The next day was 9/11. In the aftermath of the terrorist attacks, the rest of the series was cancelled, and Louisville was crowned the 2001 Champion because of their victory in the first game. (Louisville Bats.)

BASEBALL IS BACK IN A BIG WAY

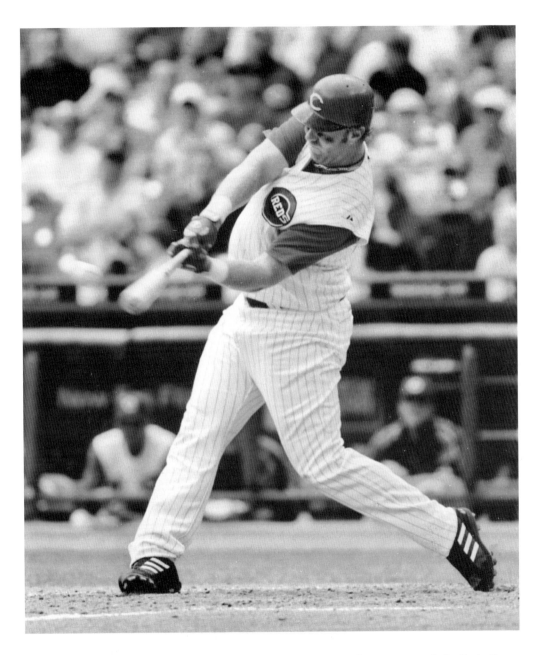

ADAM BEGAT HOMER. In his 55 games with the RiverBats in 2001, Adam Dunn smashed some memorable home runs out of Louisville Slugger Field. He launched 20 homers that season and batted .329 when the Reds scooped him up to Cincinnati. In five seasons with the Reds, Dunn has played in one All-Star Game and batted .248. He annihilated 46 home runs in 2004 and crushed another 40 in 2005. (James Sass, Louisville Slugger.)

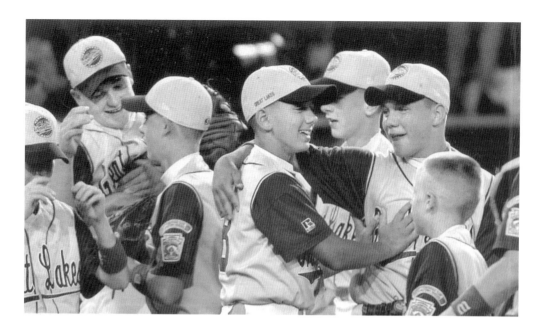

WORLD CHAMPS. In the summer of 2002, a team of young athletes captivated Louisville with their enthralling bid to bring home the Little League World Series Championship. Here Louisville's Valley Sports squad celebrates their 1-0 victory over Japan for the World Championship. (*The Courier-Journal.*)

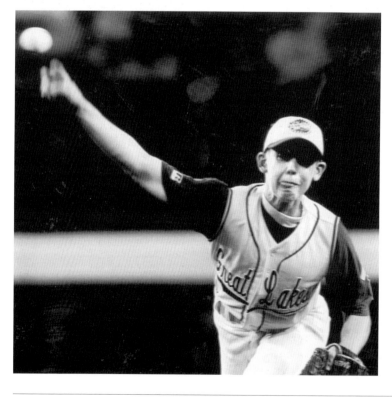

YOUNG MAN ON THE MOUND. Zach Osborne delivered throughout the Series as a pitcher and at bat. He's shown here in the U.S.A. Championship game, when he struck out 11 and pitched a two-hitter, along with zinging two hits of his own, in Louisville's 4-0 victory over Worcester, Massachusetts. (*The Courier-Journal.*)

BASEBALL IS BACK IN A BIG WAY

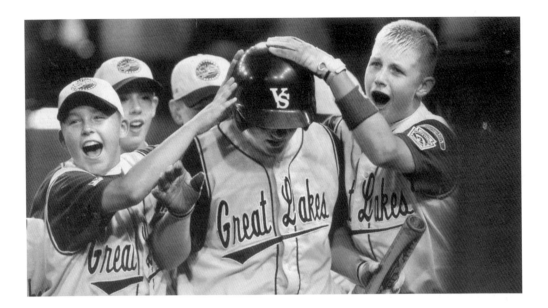

SLAP HAPPY. After hitting a home run in the 11th inning, Aaron Alvey (center) is greeted by happy teammates Josh Robinson (left) and Ethan Henry (right). In this game against the Southwest, Alvey threw a no-hitter for nine innings, a first in Little League World Series history. (*The Courier-Journal.*)

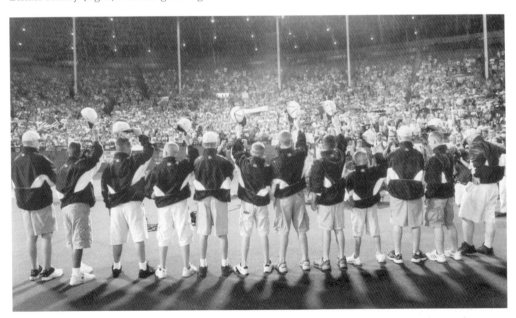

WELCOME HOME! Louisville wholeheartedly followed their hometown team during the nationally televised games. It was an emotional, uplifting, and bonding experience for the community. When Valley Sports returned home, the champions were greeted by an estimated 10,000 fans at Cardinal Stadium. (*The Courier-Journal.*)

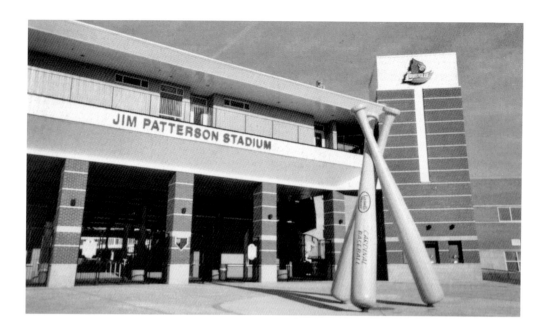

A Jewel of a Diamond. On April 15, 2005, the University of Louisville opened Patterson Stadium. The $10-million ballpark at Third Street and Central Avenue seats 2,500 and hosted the school's largest baseball crowd ever (3,213) during the inaugural game at the stadium. While the diamond is equipped with cutting-edge features, like the same Field Turf used by several major-league teams, it also pays tribute to Louisville's baseball past in a couple of very fitting ways. (Anne Jewell, Louisville Slugger Museum & Factory.)

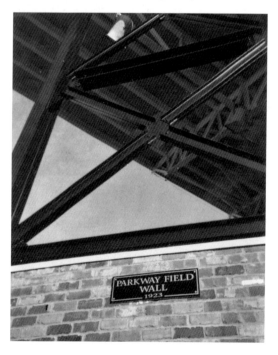

Parkway Lives On. When the university built its new baseball complex, it used bricks from Parkway's venerable left-field wall as bases for steel roof supports. Also dirt from Parkway's infield was put in the new batter's box. The dirt at Parkway had been trod by the likes of Babe Ruth, Lou Gehrig, Satchel Paige, Pee Wee Reese, Jackie Robinson, and other stars. The University of Louisville Cardinals played at Parkway from about 1961 until 1996. The Parkway-brick roof supports at Patterson Stadium are eight feet high. (Anne Jewell, Louisville Slugger Museum & Factory.)

KEEPING A GOOD THING GOING. In 2005, the Louisville Bats and Cincinnati Reds extended their affiliation through 2008, ensuring that Bats fans won't have to travel far to see their favorite players after they get called up to Cincinnati, just 90 minutes away. Here Brady Clark poses with a fan. (Louisville Bats.)

ONE FOR THE RECORD BOOKS. Chris Burke leaps toward his teammates at home plate after vaulting the Houston Astros into the 2005 National League Championship Series with a home run in the 18th inning against Atlanta. Burke's shot ended baseball's longest postseason game in history, clocking in at 5 hours and 50 minutes. Chris Burke graduated from Louisville's St. Xavier High School. (Associated Press/ Wide World Photos.)

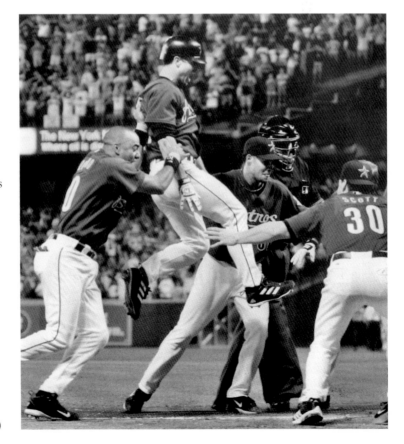

BASEBALL IN LOUISVILLE

A QUARTER CENTURY. On April 14, 2006, the home opener set a new attendance record for Louisville Slugger Field: 14,123. The 2006 season marks the 25th anniversary of the minor-league franchise that Dan Ulmer helped lure to town in 1982. They have a different name now and different owners. They play in a different stadium, and they're affiliated with a different major-league team. Much has changed. And much remains the same. The Louisville Bats still consistently finish in the top of their league for attendance, and fans of all ages have a ball at every game. (*The Courier-Journal.*)

BASEBALL IS BACK IN A BIG WAY

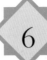

6

LOUISVILLE SLUGGER, A CONSTANT THROUGH THE YEARS

1859–PRESENT

While Louisville's professional baseball teams, players, and ballparks have come and gone over the years, the city has maintained one consistent and unique connection to baseball. This bond started humbly in a carpentry shop in 1859 and has since grown to worldwide fame.

For Louisville, one of the great things about Louisville Slugger baseball bats is that each one is emblazoned with the city's name. The association links Louisville with this legendary brand and promotes the city around the globe.

If American history and baseball history are tied together, then Louisville Slugger has been, and remains to this day, one of the ties that binds the two. But this American icon might never have come to be, without one young Louisvillian's passion for baseball.

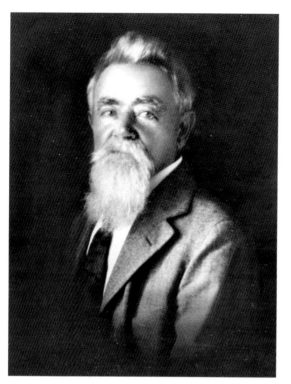

A GERMAN WOODWORKING HERITAGE.
Johann Fredrich Hillerich was born
in 1833 in Sigmaringen, Germany.
His family came to the United
States in 1842. The family trade
was woodworking, and by 1859,
J. Fredrich was running his own
woodturning business in Louisville,
Kentucky. (Louisville Slugger
Museum & Factory Archives.)

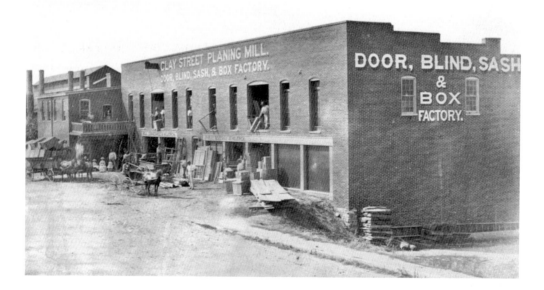

J. FREDRICH'S FIRST SHOP. This is where the dynasty began, near the shores of the Ohio River at 22 Clay Street. The Hillerich business occupied this site from about 1859 to 1875. Boxes, shutters, window frames, doors, and other products lean up against the building in this shot. No baseball bats are in sight yet, but J. Fredrich's son will change that in the coming years. (Louisville Slugger Museum & Factory Archives.)

A PASSION FOR BASEBALL. J. Fredrich's eldest son, John Andrew "Bud" Hillerich, was born in Louisville on October 15, 1866. Bud was a big fan of baseball and even played amateur ball in Louisville's active baseball scene. He is credited with making the company's first baseball bat in 1884. Bud pushed his reluctant father toward the bat-making business. J. Fredrich strongly opposed this notion, convinced that the future of the company rested with a revolutionary and patented product: the swinging butter churn. (Louisville Slugger Museum & Factory Archives.)

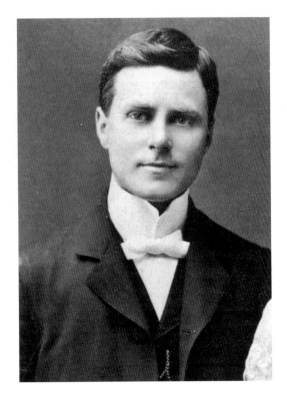

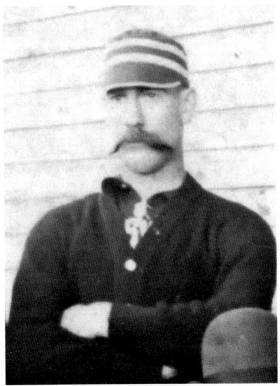

THE LOUISVILLE SLUGGER. Although several stories exist regarding the first professional player to use a Hillerich-made bat, the company believes 17-year-old Bud Hillerich made that first bat for Pete Browning, the great hitter for the Louisville Eclipse. In 1884, Bud was an apprentice in his father's shop and skipped work one day to watch the Eclipse play. Browning was in a slump, and to make matters worse, he broke his bat. Bud offered to turn him a new one, which Browning used the next day and got several hits. The business grew from there. The bat would not be trademarked as "Louisville Slugger" until 1894, but that had been one of Browning's nicknames during his playing career. (Louisville Slugger Museum & Factory Archives.)

HEY BUTTER, BUTTER, BUTTER . . . SWING! The swinging butter churn was a very successful product for the Hilleriches for a number of years. The girl here is Cletus Hillerich, Bud's daughter. She grew up to be an instrumental force in the company's success. Cletus provided pivotal leadership during a time of crisis after both of her brothers, Ward and Junie, had died. (Louisville Slugger Museum & Factory Archives.)

ON THE THRESHOLD OF A NEW CENTURY. This photograph is dated between 1887 and 1892, when the company was located at 116 South First Street. The business moved here around 1875, so this is where the first baseball bat was made. Bats are displayed in this shot, along with a bedpost and a swinging butter churn. Pictured from left to right are Henry W. Bickel; J. Fredrich Hillerich; two unidentified blacksmiths from the neighboring business, Bill Meyers, Bud Hillerich holding a bat on top of a churn, an unidentified boy, Jim Ball, and Dave Kunz. (Louisville Slugger Museum & Factory Archives.)

TIMBER! A handwritten notation on the back of this shot identifies it as a "very old bat timber photo." Over the years, Hillerich & Bradsby Co. (H&B) has made its Louisville Slugger bats out of ash, hickory, willow, oak, beech, hackberry, and maple. Today bat production is split almost evenly between northern white ash and maple lumber grown in Pennsylvania and New York. The ideal trees for baseball bats are grouped close together so they grow straight and tall. It takes about 40,000 trees to make a season's worth of bats. (Louisville Slugger Museum & Factory Archives.)

"OLD HICKORY." A wagonload of lumber destined for the diamond is ready for a bumpy ride to the workshop. This is one of Louisville Slugger's early bat timber yards, probably sometime around the beginning of the 20th century. (Louisville Slugger Museum & Factory Archives.)

(Opposite) A BAT IN THE MAKING. While the technology used to shape bats has advanced over the years, the stages in the production process look about the same as they did back in the 19th century. Starting at the bottom of the picture, a split fresh from the forest still has the bark on it. Next it's turned on a lathe. The rounded shape is called a billet, which is French for "tree trunk." This is how the bats look when they arrive at the factory in Louisville. The rectangular shape above it used to come from larger trees, which were rip-sawn into squares in years past. The handle starts to take shape in the next stage, called a rough-out. The rough-out stage isn't necessary with the automatic lathes now used. The bat really begins to emerge after that. It has "nubs" at each end to hold it in place in the bat-making machinery. Next come finishing touches, like the oval brand and player signature—in this case, Hall of Famer Johnny Bench. (Louisville Slugger Museum & Factory Archives.)

LOUISVILLE SLUGGER

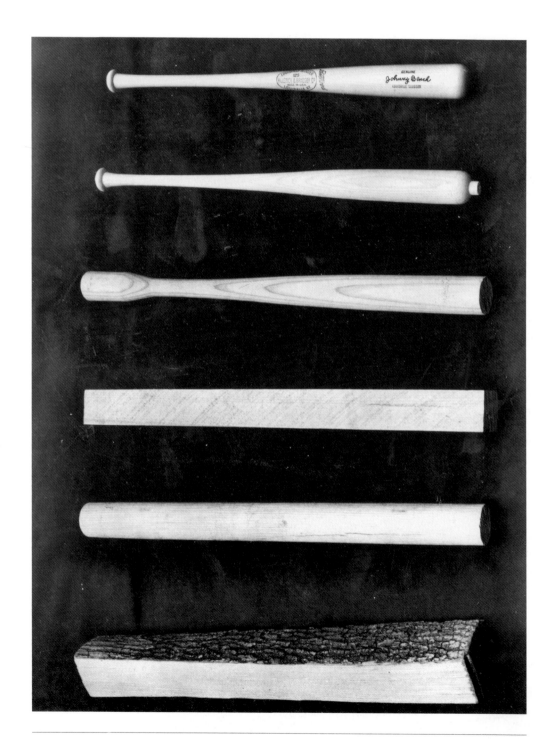

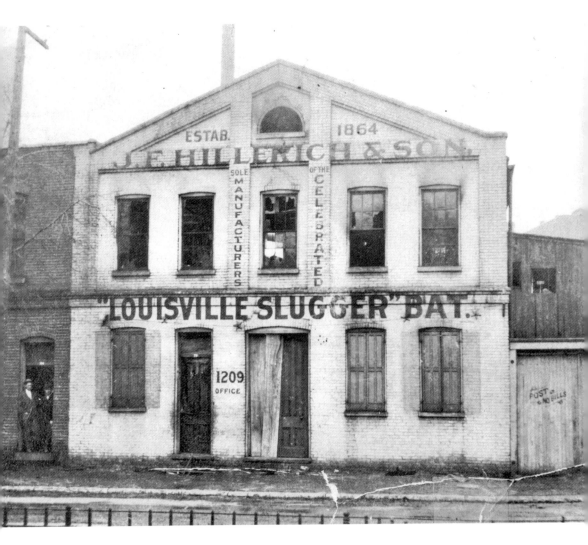

Sole Manufacturers. The dilapidated, abandoned building shown here still proudly proclaims its connection to the Hillerich bat-making business; 1209 South Preston Street, between Finzer and Jacob Streets, was the office for the third location of the growing company from 1901 to 1925. (Louisville Slugger Museum & Factory Archives.)

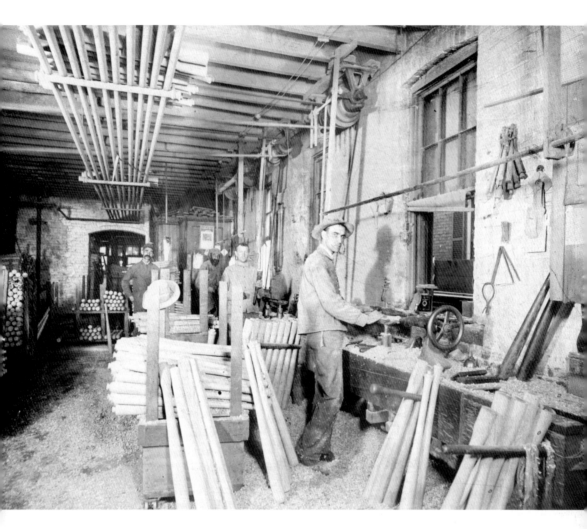

KNEE DEEP IN WOOD SHAVINGS. Here is the scene inside 1209 South Preston Street *c.* 1903. This is the hand-turning room, where bats took shape with the help of steam-powered lathes that were turned by belts suspended from the ceiling. Pictured from left to right are Henry Bickel, Doc Shrader, Bill Goepper, and John Ackerman. (Louisville Slugger Museum & Factory Archives.)

Form 1918a Rev.

HILLERICH & BRADSBY CO.
INCORPORATED
SOLE MANUFACTURERS OF THE CELEBRATED
"LOUISVILLE SLUGGER" BASE BALL BATS
436 FINZER STREET
LOUISVILLE 2, KY.

AGREEMENT

For valuable considerations in hand paid, the receipt of which is hereby acknowledged, and for other good and valuable considerations, I, the undersigned, hereby grant unto Hillerich & Bradsby Co., a corporation of Kentucky, its successors and assigns, the sole and exclusive use of my name, autograph, portrait, photograph, picture, initials, and /or nickname, for trademark and/or advertising purposes in connection with the manufacture and/or sale of baseball bats, and I hereby consent to the registration of any such material as a trade-mark for baseball bats by said Hillerich & Bradsby Co.

I hereby endorse and have bona fide used or will so use the bats made by Hillerich & Bradsby Co. and having my name associated therewith, and warrant that I have not previously made any agreement, assignment, or license in conflict herewith.

EXECUTED in duplicate this _4_ day of _March_, 19_44_

at _Lakeland, Fla_

Albert Kaline (SEAL)
Player's Signature—Full Name

WITNESS:

Frank J. Ryan
Signature

ALBERT KALINE

Home Address _2222 Cedley St — Baltimore, 30, Md_

Club _Detroit_ Position _Outfield_

Age _19_ Height _6'1"_ Weight _175_ Birth: Yr. _1934_ Mo. _12_ Day _19_

Sign on these lines three or four times the way you wish your name to appear on Louisville Sluggers.

← use this auto —

Al Kaline

Al Kaline

OK
JR
3/4/54

Bat Model _R188Y_ Length _34 1/2_ Weight _32_

Ship to _Home_

LET'S MAKE A DEAL. On September 1, 1905, Honus Wagner became the first player to sign a contract with Louisville Slugger and the first to have his signature branded on his bats. This was also the very first example of a professional athlete endorsing an athletic product. It is likely that no money was exchanged for the endorsement but that Wagner received free bats. He would have been familiar with the product and the Hillerich family, given his time in Louisville. Since Wagner's first agreement, over 8,000 players have signed with Louisville Slugger. This contract was signed by 19-year-old Al Kaline, a future Hall of Famer, in 1954. Back then, the signature was actually cut out from the contract and used to make the brand for the player's bat. It was typical for Louisville Slugger to offer PowerBilt golf clubs, another H&B product, and perhaps up to $100 to players as part of the deal. Contracted players to this day are assured top-notch customer service that places their orders ahead of any that come in from non-contract players. (Louisville Slugger Museum & Factory Archives.)

BRADSBY COMES ABOARD. While the Hillerich family knew how to produce great bats, the company lacked a strong marketing and sales effort until Frank Bradsby came aboard in 1911. Bradsby worked at Simmons Hardware in St. Louis, Missouri, where he was a buyer for the store's athletic goods department. He was a brilliant marketer who came up with the idea of promoting replicas of professional player bats to youngsters. Bradsby died in 1937 after exerting himself substantially following the disastrous Ohio River flood that ravaged a number of states that year. He had no immediate heirs, but out of respect for everything he did for the company, Bradsby's name remains a part of Hillerich & Bradsby Co. to this day. (Louisville Slugger Museum & Factory Archives.)

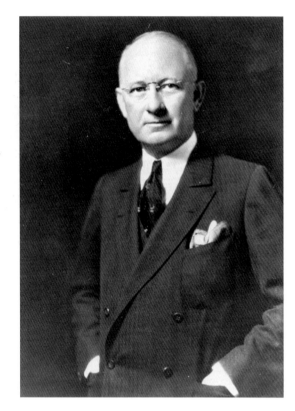

FAMOUS SLUGGERS. Part of Louisville Slugger's marketing efforts included an annual publication called *Famous Sluggers*. The booklets were distributed at stores and in promotional offers from the 1920s through the 1970s. They included tips on batting and caring for bats, statistics, history, photographs, and more. This example is from 1936 and features Hall of Famers Mel Ott (left) and Lou Gehrig on the cover. (Louisville Slugger Museum & Factory Archives.)

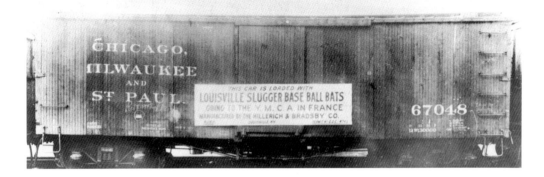

RUSH. The banner on this train explains the special cargo it carried to American soldiers in France during World War I. (YMCA of the USA Archives, University of Minnesota Libraries.)

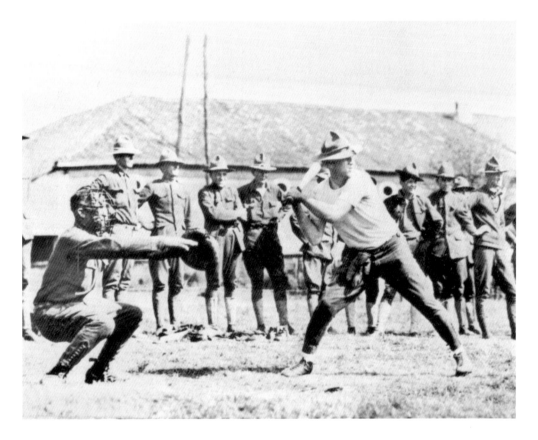

A BIG HIT. American soldiers in France take a break and play some ball during World War I. H&B's involvement with World War I started an ongoing tradition of the company supporting American troops during wartime. (Louisville Slugger Museum & Factory Archives.)

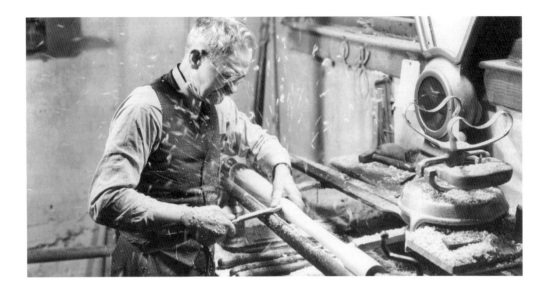

WATCH OUT FOR FLYING WOODCHIPS. Hand-turner Henry Bickel shapes a baseball bat on his lathe. Bickel worked for Louisville Slugger for almost 60 years, from 1883 to 1942. When bats were turned by hand, each one took up to 30 minutes to create. These days, professional player bats are turned out in about 45 seconds with special computerized lathes. At one time, Louisville Slugger produced 6 million wooden bats a year; now the company makes about a million annually. The reason for the drop is aluminum bats, which Louisville Slugger started producing in 1970. Today the company makes over 1 million TPX and TPS aluminum and composite bats a year. (Louisville Slugger Museum & Factory Archives.)

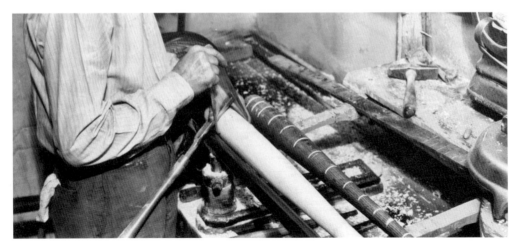

MEASURE MARKS. Since the beginning of the business, every single Louisville Slugger professional bat has been made to the specifications of each individual player. Back when bats were turned by hand, the process involved frequent measuring with calipers to make sure the bat being turned matched the model bat. The measure points on this particular model are marked with white lines. (Louisville Slugger Museum & Factory Archives.)

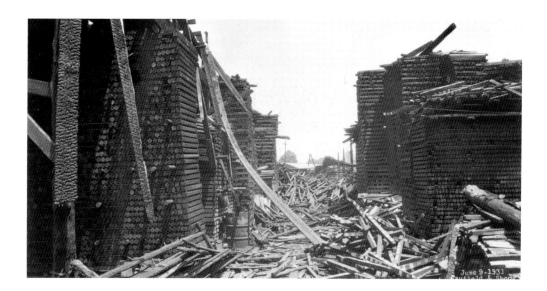

ALWAYS A THREAT. In June 1931, two million pieces of H&B timber went up in flames at the company's Preston Street lumberyard. The fire destroyed about $500,000 in ash and hickory. H&B had enough timber at other yards to stay in business. About 20 years earlier, fire had also gutted the bat factory building. (University of Louisville Photographic Archives.)

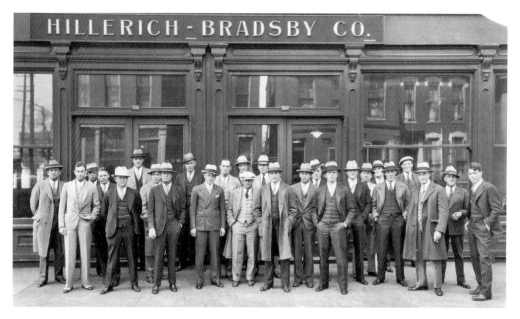

SHARP-DRESSED REDS. It was not unusual for players and teams to stop by the bat factory if they were in town for a game or passing through around spring training. This gang is the Cincinnati Reds, in front of H&B's offices c. 1931. On the far right is Ward Hillerich, Bud's eldest son. He served as CEO for the company from 1946 until his death in 1949. (Louisville Slugger Museum & Factory Archives.)

SOGGY TIMBER. In 1937, the Ohio River wreaked havoc for miles as it crested almost 30 feet over flood level and covered about 70 percent of the city. Pictured here are mounds of soggy lumber in H&B's timber yard. The bat factory was even closer to the river. Some machinery was taken upstairs as floodwaters approached, but some equipment could not be moved. The water was three feet deep in the factory, and when it receded, the workers returned to find swollen bats scattered all over the floors. Racks and machinery had to be rebuilt. (Louisville Slugger Museum & Factory Archives.)

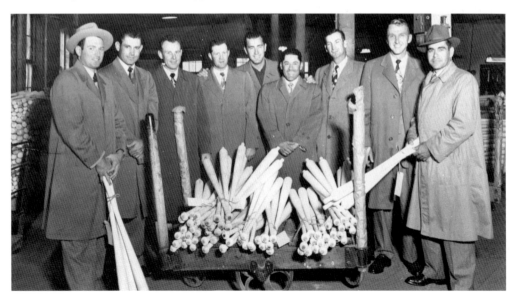

BUNDLES OF BATS. The Detroit Tigers gather around a factory cart loaded with Louisville Slugger bats on April 14, 1950. Pictured from left to right are George Kell (elected to the Hall of Fame in 1983), Johnny Lipon, George Lerchen, Neil Berry, Don Kolloway, Eddie Lake, Pat Mullin, Dick Kryhoski, and Charley Keller. (Louisville Slugger Museum & Factory Archives.)

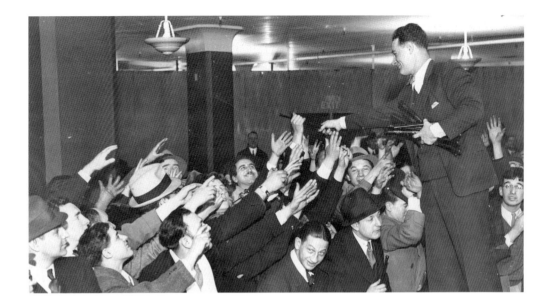

THE MIGHTY MINI-BAT. Over the years, Louisville Slugger has produced millions of miniature souvenir bats ranging in size from 10 to 18 inches. They have often been used for promotional purposes. Here Lou Gehrig hands out mini-bats at the Macy's store in New York City *c.* 1935. To this day, visitors to Louisville Slugger Museum & Factory are excited to receive their very own mini-bat at the end of their tour. (Louisville Slugger Museum & Factory Archives.)

MINI-BAT PRACTICE. Some young fans with Louisville Slugger mini-bats mimic Leroy Anton and his full-sized version of the same thing. Anton played first base from 1928 to 1936 with the Oakland Oaks in the Pacific Coast League. (Louisville Slugger Museum & Factory Archives.)

MINI DiMAGGIO. Dom DiMaggio's son, Paul, looks ready for the big leagues with his very own uniform and mini-bat. (Louisville Slugger Museum & Factory Archives.)

SPLENDID SPLINTER SMOOCHES SLUGGER. Ted Williams shows affection for his Louisville Slugger baseball bat on September 28, 1941. He had just ended the season with a .406 average. No player has achieved a .400 season since. Williams was inducted into the Hall of Fame in 1966. (Louisville Slugger Museum & Factory Archives.)

LIP SERVICE. Joe DiMaggio puckers up and plants one on his Louisville Slugger bat. DiMaggio hit in 56 straight games in 1941, the same year Ted Williams batted .406. The 56-game streak is still a record today. H&B owns the only bat known to be used by DiMaggio during the streak. He entered the Hall of Fame in 1955. (Louisville Slugger Museum & Factory Archives.)

THAT'S AMORE! Rocky Colavito knows a good bat when he kisses one. Colavito belted 374 home runs in his 14-year major-league career. (Louisville Slugger Museum & Factory Archives.)

WOMEN'S WORK. During World War II, H&B made M-1 carbine gunstocks and tank pins. Like most other factories at the time, women did the work. It was the first time that females were employed in the factory. H&B also made bats and other sports equipment for soldiers. The company was presented with the Army-Navy "E" Award for excellence in producing items vital for victory in the war. (Louisville Slugger Museum & Factory Archives.)

SHARING AMERICA'S FAVORITE PASTIME. Ira Scribner, a metalsmith with the U.S. Navy, gives a couple of youngsters in Guam some tips on baseball. With the help of Louisville Slugger equipment, Scribner organized a team of Guam locals during World War II. On the other side of the globe, a Louisvillian being held in a German prison camp never forgot the day when some sports equipment showed up. Decades later, Dr. Carroll Witten told H&B that the goods included Louisville Slugger bats. About 26 of the American prisoners of war were from Kentucky, and tears were shed when they saw the bats, a poignant reminder of home. (Louisville Slugger Museum & Factory Archives.)

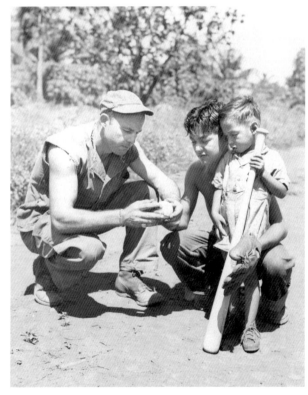

HILLERICH & BRADSBY COMPANY, INC., LOUISVILLE, KY.

Published Monthly at Tenth and Olive Streets, St. Louis, Mo. Subscription rates $2.00 a year in U. S., $3.00 in Canada, and $3.50 in Foreign Countries Entered as second-class matter at Postoffice, St. Louis, Mo., October, 1899, under Act of Congress, March 3, 1879.

THINGS WHICH SLAY. Louisville Slugger addresses Joseph Goebbels directly in this advertisement from the World War II era. Goebbels was Adolph Hitler's minister of propaganda. H&B wanted him to know that "we who build so well for play—do equally well with things which slay," a reference to the M-1 carbine gunstocks and tank pins being produced by H&B for the war. Goebbels ended up shooting himself after Hitler committed suicide. (Louisville Slugger Museum & Factory Archives.)

WELCOME BACK, BOYS. In April 1946, these members of the Boston Red Sox made their first postwar visit to the factory. All of them were war veterans. Pictured from left to right are Ted Williams, Mickey Harris, Dom DiMaggio, Paul Campbell, Johnny Pesky, and Bobby Doerr, who was inducted into the Hall of Fame in 1986. (Louisville Slugger Museum & Factory Archives.)

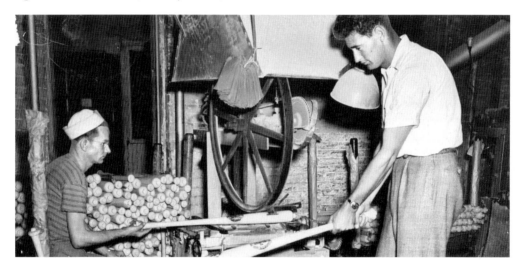

HANDS-ON HITTER. Ted Williams said he felt like a "kid in a toy factory" whenever he visited the Louisville Slugger bat factory. During his regular pilgrimages, Williams selected his own lumber, preferring bats with little pin knots. Williams was so particular about his bats that he once sent a batch back to the factory, saying the handles didn't feel right. Workers measured them against the model he'd been using. The new bats were indeed different from his model—the handles were 5/1000ths of an inch off. Williams is shown here at the burn-branding station with Howard Smith. (Louisville Slugger Museum & Factory Archives.)

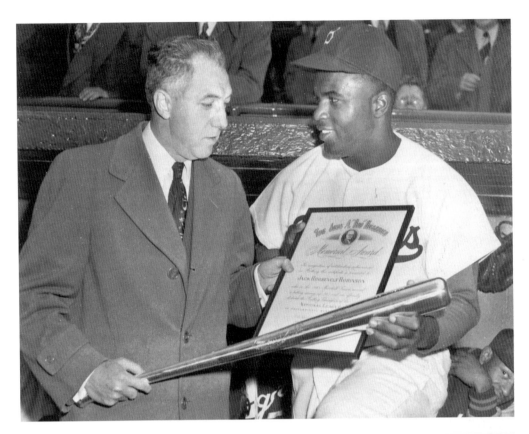

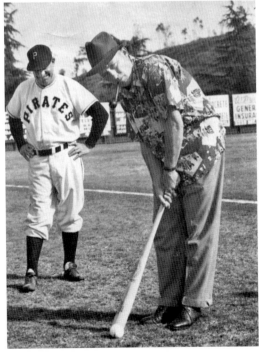

SILVER BAT AWARD. Louisville Slugger presents the Silver Bat Award annually to the batting champions of each league. The first awards were given out in 1949 to American League champ George Kell and National League honoree Jackie Robinson, shown here with his award and league president Ford Frick. (Louisville Slugger Museum & Factory Archives.)

BADA-BING. World-famous crooner Bing Crosby tees off with his Louisville Slugger bat at the Pittsburgh Pirates' training camp in 1950. Crosby was part owner of the team. Manager Bill Meyer looks on. Meyer played with the Louisville Colonels for eight years, took over as Louisville's manager in 1926, and won a pennant his first year at the helm. (Louisville Slugger Museum & Factory Archives.)

VERY FUNNY. NOW WHERE'S MY BOUQUET? Miss Baseball 1954 is presented with a personalized Louisville Slugger baseball bat at the minor-league convention in Houston, Texas. (Louisville Slugger Museum & Factory Archives.)

A LEG UP ON QUALITY CONTROL. At Kennedy Airport in New York City, 50 dozen Louisville Slugger bats bound for Venezuela get the once-over by Pan Am cargo clerk Marilyn Kelly. (Louisville Slugger Museum & Factory Archives.)

SISTER MARY SLUGGER. At the National Catholic Education Convention in 1958, two nuns seem to relish the thought of replacing their little rulers with something more substantial. (Louisville Slugger Museum & Factory Archives.)

TALKIN' TIMBER. John A. Hillerich Jr., also known as "Junie" (center), was the son of Bud Hillerich, who made the company's first baseball bat in 1884. When this shot was taken in 1958, Junie was president of H&B. He's pictured with his sons, Jack III (left) and Hart. Jack III was president of the company from 1969 to 2001 and still serves as chairman of the board. Hart worked in production and maintenance for H&B. His sons, Tom, Bob, and Brian, currently work with the company. (Louisville Slugger Museum & Factory Archives.)

MAN YOUR STATION. Whipping out World Series bats is a drill Louisville Slugger knows well. Here's a batch being loaded into a company station wagon for a quick drive to the airport and a rush air shipment. Because the teams in the World Series sometimes aren't known until shortly before the games begin, the bat factory often has a tight, challenging turnaround to produce and deliver the customized sticks. (Louisville Slugger Museum & Factory Archives.)

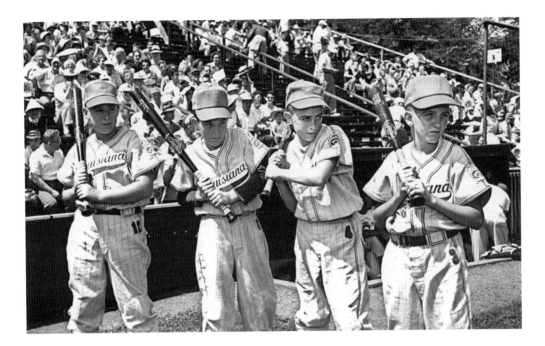

SHOW US YOUR STANCE. At the Little League World Series in Williamsport, Pennsylvania, some boys from Louisiana look prepared to put their Louisville Slugger bats to good use. (Louisville Slugger Museum & Factory Archives.)

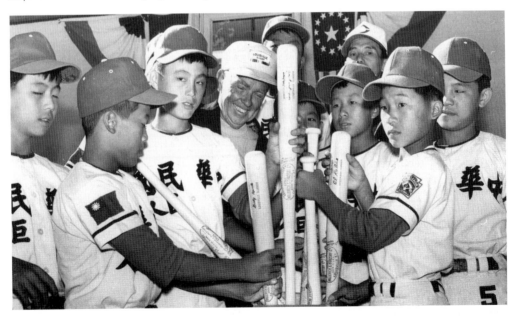

GLOBAL RECOGNITION. Louisville Slugger salesman Stanley Kazmark comes calling with a box of goodies for this Asian team at the Little League World Series. Kazmark worked for H&B from 1945 to 1977. (Louisville Slugger Museum & Factory Archives.)

BASEBALL IN LOUISVILLE

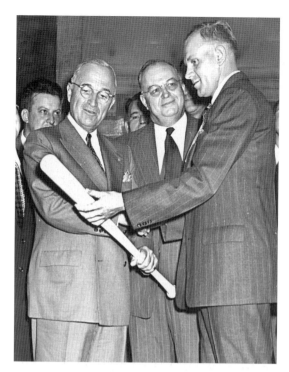

THE BAT STOPS HERE. On September 30, 1948, Pres. Harry S Truman was presented with a personalized bat by Vernon Larsen (right), a factory employee. Between them, Kentucky governor Earle Clements made the most of a good photo op. (Louisville Slugger Museum & Factory Archives.)

"I FEEL YOUR GRAIN." Pres. Bill Clinton swings by Louisville Slugger Museum & Factory in 1996. He is pictured here with Jack Hillerich III, company president at the time. (Louisville Slugger Museum & Factory Archives.)

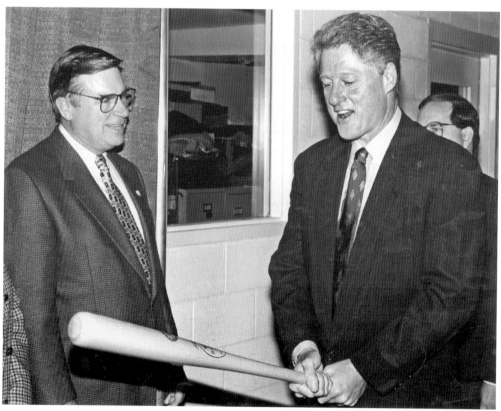

BUSHWHACKER. While campaigning for the presidency in 2000, George W. Bush had a rally at Louisville Slugger Museum & Factory. Here he checks out a bat with factory worker Wendell Wariner, who has worked for H&B since 1969. (Louisville Slugger Museum & Factory Archives.)

NOW BATTING FOR THE VATICAN . . . Pope John Paul II was given a personalized Louisville Slugger bat in 2005 by Marco Sfzora (right), an Italian sporting goods distributor with Rus International. (Louisville Slugger Museum & Factory Archives.)

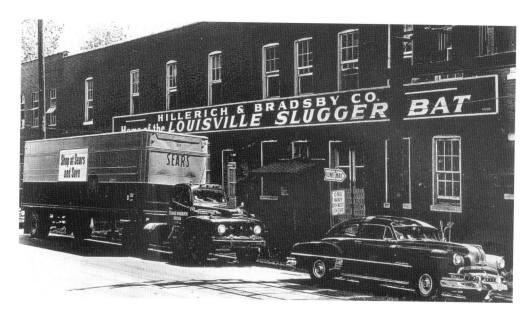

GROWING COMPANY. A Sears semitruck is parked outside the company's offices at Jackson and Finzer Streets. H&B expanded into this location in 1925. (Louisville Slugger Museum & Factory Archives.)

"DOES YOUR MOTHER KNOW ABOUT THIS?" For over 20 years, Louisville Slugger bats were produced just across the Ohio River from Louisville in Jeffersonville, Indiana. Then-president Jack Hillerich decided to make the move in the early 1970s because the company needed more space. The corporate headquarters remained in Louisville; only the factory moved. When H&B's vice president of advertising and public relations, Jack McGrath, realized what had been decided, he exclaimed, "Oh, my God! Do you know what you've done?" Jack Hillerich's wife also chimed in with, "Does your mother know about this?" Here is an aerial view of the bat factory, known as Slugger Park, in Jeffersonville. The skyline of downtown Louisville is on the upper right side. (Louisville Slugger Museum & Factory Archives.)

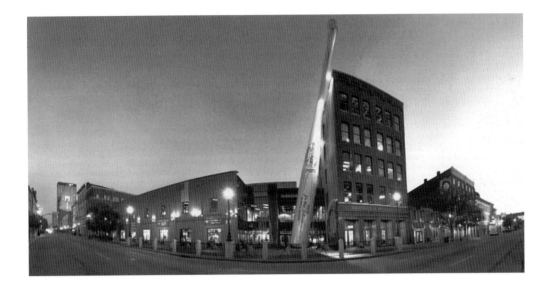

WORLD'S BIGGEST BAT. Bat production came back to Louisville in 1996, when H&B moved into its new factory and headquarters at 800 West Main Street, just seven blocks from where the company made its first baseball bat in 1884. A huge, exact-scale replica of Babe Ruth's bat marks the entrance to Louisville Slugger Museum & Factory. The steel bat is 120 feet tall, weighs 68,000 pounds, and is hand painted to look like wood. Bud Hillerich's signature is on the bat as a tribute to the man who made the company's first baseball bat. About 200,000 visitors a year tour the museum and factory. (Louisville Slugger Museum & Factory Archives.)

DIP LINE. Louisville Slugger bats are still dipped by hand in clear or colored lacquer and hung to dry. James O'Daniel dips bats for Don Mattingly. Players today can choose from about 16 different color combinations and also specify features like weight, length, knob, and wood type. O'Daniel worked for H&B for 30 years. (Louisville Slugger Museum & Factory Archives.)

YESTERDAY'S TOUR. Presidents and professional ballplayers aren't the only people allowed to tour Louisville Slugger's bat factory. In fact, the company has provided tours to the public for so many years that H&B is not certain how long ago they actually began. These women take in the burn-branding station in the 1940s. (Louisville Slugger Museum & Factory Archives.)

TODAY'S TOUR. At one time, bat factory tours were conducted only twice a day. Now up to 50 tours go through on a busy summer day. Following in the footsteps of bygone guests, visitors still get to walk right through the heart of the factory floor. (Louisville Slugger Museum & Factory Archives.)

THE INCOMPARABLE BABE. Babe Ruth signed his original contract with Louisville Slugger on June 20, 1918, for $100. He once placed an order for gargantuan 52-ounce bats, but there's no record that he actually used one in a game. Still, over the course of his career, he swung bats weighing from 39 to 47 ounces, significantly heavier than today's average weight of 31 ounces. Here the Bambino trades tips with a couple of young players. Ruth was among the first group of players elected to the Hall of Fame in 1936. (Louisville Slugger Museum & Factory Archives.)

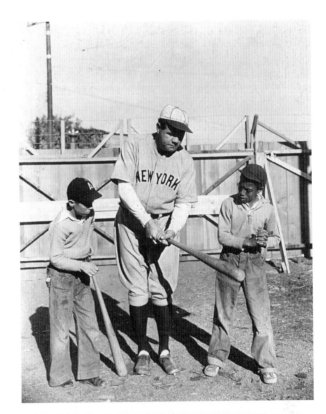

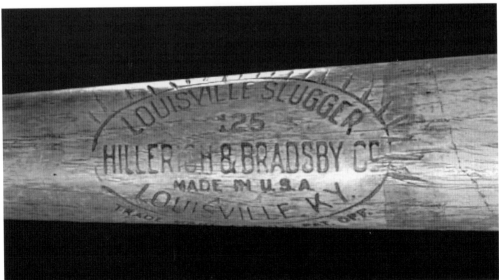

NOTCHED BAT. One of Louisville Slugger Museum & Factory's most prized possessions is this Babe Ruth bat. The Sultan of Swat carved notches along the top of the oval trademark for every home run he hit with it in 1927, the year he slammed his record-setting 60 home runs. There are 21 notches in the bat. (Louisville Slugger Museum & Factory Archives.)

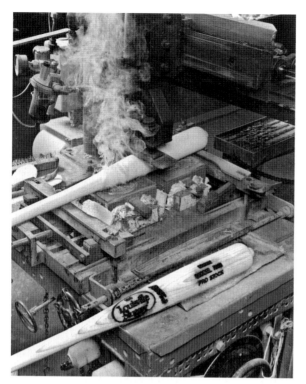

THE FLAT OF THE GRAIN. Bats are carefully branded on what's called the "flat of the grain," where the wood grain forms points down the length of the bat. It's the weakest part of the lumber. Players are instructed to "keep the trademark up," so they will be less likely to break the bat when they come around on their swing and make contact with the ball. (Louisville Slugger Museum & Factory Archives.)

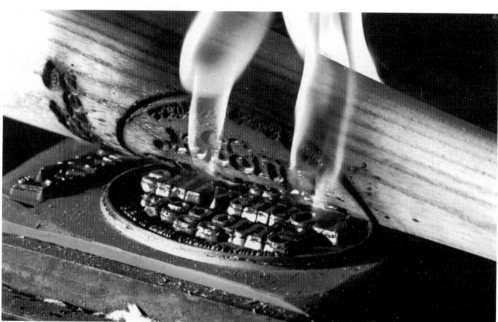

SEARED TO PERFECTION. At one time, all bats were rolled over a hot plate for branding. This process is used much less frequently today because more bats are also branded by hand with decals or with gold, silver, or black foil. (Louisville Slugger Museum & Factory Archives.)

SILVER SLUGGER TEAM.
Louisville Slugger created the
annual Silver Slugger Team in
1980. This special honor goes
to the top offensive performers
at each position in both
leagues. The Silver Slugger
Team lineup is voted on by
coaches and managers, who
select players they'd most like
to have on their team, based
on a combination of offensive
stats and their personal
impressions of a player's overall
abilities swinging a bat. Hard-
hitting Ivan Rodriguez (right)
has been named to the Silver
Slugger Team seven times,
while Miguel Tejada (below)
has earned the honor twice.
Both players have contracts
with Louisville Slugger. (James
Sass, Louisville Slugger.)

OPERATION SLUGGER. In 2005, Louisville Slugger continued its long-running support of U.S. troops during wartime. This rally at Louisville Slugger Museum & Factory kicked off Operation Slugger, a team effort with USA Cares, DHL, Veterans of Foreign Wars, and the Association of the United States Army. Operation Slugger collected and delivered sports equipment to troops stationed in Iraq and Afghanistan. On the left is Louisville mayor Jerry Abramson. John Hillerich IV, president and CEO of H&B, stands in the background directly behind the DHL box brimming with sporting goods, including Louisville Slugger bats and gloves. The company started making gloves in 1975. (Barry Westerman.)

STILL MAKING HISTORY. Up to 70 percent of today's major-league players use Louisville Slugger baseball bats, the official bat of Major League Baseball. Sticks today have thinner handles and are more lightweight compared to the relative tree trunks swung by the likes of Babe Ruth and Lou Gehrig in the first half of the 20th century. Here Derek Jeter is about to use his Louisville Slugger bat to produce that classic, satisfying sound that has thrilled fans since the game's beginnings in the 19th century: the unmistakable "crack of the bat." (James Sass, Louisville Slugger.)

FROM OUR FAMILY TO YOURS. As Hillerich & Bradsby Co. approaches the 125th anniversary of its Louisville Slugger baseball bat, it remains a privately held, family-owned business. This impressive longevity is directly related to H&B's commitment to customer service and product innovation. Just as generations of the Hillerich family have invested their lives in the business, so too have generations of families worldwide happily adopted Hillerich-made products into their own lives. (Louisville Slugger Museum & Factory Archives.)

BIBLIOGRAPHY

Bucek, Jeanine, ed. *The Baseball Encyclopedia.* 10th ed. New York: Macmillan, 1996.

The Courier-Journal.

Crews, Clyde F. *Survey and Headline History of Louisville Baseball Highlights.* Unpublished manuscript, 1992.

The Daily Democrat.

DeValeria, Dennis and Jeanne Burke DeValeria. *Honus Wagner: A Biography.* New York: Henry Holt, 1996.

Hill, Bob. *Crack of the Bat: The Louisville Slugger Story.* Champaign, IL: Sports Publishing, 2000.

http://www.aagpbl.org

http://www.baseball-reference.com

http://www.batsbaseball.com

http://www.minorleaguebaseball.com

http://www.sluggermuseum.org

http://www.thebaseballcube.com

Johnson, Lloyd and Brenda Ward. *Who's Who In Baseball.* New York: Barnes and Noble, 1994.

Kleber, John E., ed. *The Encyclopedia of Louisville.* Lexington, KY: The University Press of Kentucky, 2001.

The Louisville Commercial.

The Louisville Journal.

The Louisville Times.

Lowry, Philip J. *Green Cathedrals.* Cooperstown, NY: Society for American Baseball Research, 1986.

Puckett, Ron, Mary Helen Butler-Clark, and Elaine Rhodes. *Memories of Louisville Baseball.* PCR Publications, 1983.

Reidenbaugh, Lowell. *Cooperstown: Baseball's Hall of Fame.* New York: Gramercy Books, 1997.

Riley, James A. *The Biographical Encyclopedia of the Negro Baseball League.* New York: Carroll and Graff Publishers, 1994.

Rorrer, George. *The Redbirds: A Love Affair.* Louisville, KY: The Courier-Journal and the Louisville Times Company, 1982.

————. *Redbirds: Thanks a Million.* Louisville, KY: The Courier-Journal and the Louisville Times Company, 1983.

Shatzkin, Mike. *The Ballplayers.* New York: The Idea Logical Press, 1999.

Society for American Baseball Research. *A Celebration of Louisville Baseball in the Major and Minor Leagues.* Society for American Baseball Research, 1997.

Solomon, Burt. *The Baseball Timeline.* New York: DK Publishing, 2001.

Sumner, Benjamin Barrett. *Minor League Baseball Standings.* Jefferson, NC: McFarland, 2000.

The Sporting News.

Tarvin, A. H. *Seventy-Five Years on Louisville Diamonds.* Schuhman Publications, 1940.

Thorn, John and Pete Palmer, eds. *Total Baseball.* New York: Warner Books, 1989.

Von Borries, Philip. *Louisville Diamonds: The Louisville Major-League Reader 1876–1899.* Paducah, KY: Turner Publishers, 1996.

Wright, Marshall D. *The American Association.* Jefferson, NC: McFarland, 1997.